National Standards for Arts Education

National Standards for Arts Education

What Every Young American Should Know and Be Able to Do in the Arts

Published in partnership with
MENC: The National Association for Music Education
Frances S. Ponick, Executive Editor

Rowman & Littlefield Education
Lanham • New York • Toronto • Plymouth, UK

Published in partnership with
MENC: The National Association for Music Education

Published in the United States of America
by Rowman & Littlefield Education
A Division of Rowman & Littlefield Publishers, Inc.
A wholly owned subsidiary of The Rowman & Littlefield Publishing Group, Inc.
4501 Forbes Boulevard, Suite 200, Lanham, Maryland 20706
www.rowmaneducation.com

Estover Road
Plymouth PL6 7PY
United Kingdom

British Library Cataloguing in Publication Information Available

Library of Congress Control Number: 2006929648

ISBN-13: 978-1-56545-036-3
ISBN-10: 1-56545-036-1

♾™ The paper used in this publication meets the minimum requirements of
American National Standard for Information Sciences—Permanence of
Paper for Printed Library Materials, ANSI/NISO Z39.48-1992.
Manufactured in the United States of America.

Contents

PREFACE

DEFINING TERMS

Art, the Arts Disciplines, and the Arts

In discussing these Standards for arts education, some brief definitions may be useful.

In this document, **art** means two things: (1) creative works and the process of producing them, and (2) the whole body of work in the art forms that make up the entire human intellectual and cultural heritage. When we study art, we involve ourselves in a particular set of processes, products, influences, and meanings. We recognize that art is expressed in various styles, reflects different historical circumstances, and draws on a multitude of social and cultural resources.

We use the terms **arts discipline** and **art form** to refer to Dance, Music, Theatre, and the Visual Arts, recognizing that each of these encompasses a wide variety of forms and sub-disciplines.

When this document speaks of **the arts,** it means these arts disciplines taken together or, most inclusively, the totality of all activities in the arts. Following the Standards, a glossary is presented that defines how various terms from each of the arts disciplines are used.

INTRODUCTION

Discovering Who We Are

The arts have been part of us from the very beginning. Since nomadic peoples first sang and danced for their ancestors, since hunters first painted their quarry on the walls of caves, since parents first acted out the stories of heroes for their children, the arts have described, defined, and deepened human experience. All peoples, everywhere, have an abiding need for meaning—to connect time and space, experience and event, body and spirit, intellect and emotion. People create art to make these connections, to express the otherwise inexpressible. A society and a people without the arts are unimaginable, as breathing would be without air. Such a society and people could not long survive.

The arts are one of humanity's deepest rivers of continuity. They connect each new generation to those who have gone before, equipping the newcomers in their own pursuit of the abiding questions: Who am I? What must I do? Where am I going? At the same time, the arts are often an impetus for change, challenging old perspectives from fresh angles of vision, or offering original interpretations of familiar ideas. The arts disciplines provide their own ways of thinking, habits of mind as rich and different from each other as botany is different from philosophy. At another level, the arts are society's gift to itself, linking hope to memory, inspiring courage, enriching our celebrations, and making our tragedies bearable. The arts are also a unique source of enjoyment and delight, providing the "Aha!" of discovery when we see ourselves in a new way, grasp a deeper insight, or find our imaginations refreshed. The arts have been a preoccupation of every generation precisely because they bring us face to face with ourselves, and with what we sense lies beyond ourselves.

The arts are deeply embedded in our daily life, often so deeply or subtly that we are unaware of their presence. The office manager who has never studied painting, nor visited an art museum, may nevertheless select a living-room picture with great care. The mother who never performed in a choir still sings her infant to sleep. The teenager who is a stranger to drama is moved by a Saturday night film. A couple who would never think of taking in a ballet are nonetheless avid square dancers. The arts are everywhere in our lives, adding depth and dimension to the environment we live in, shaping our experience daily. The arts are a powerful economic force as well, from fashion, to the creativity and design that go into every manufactured product, to architecture, to the performance and entertainment arts that have grown into multibillion dollar industries. We could not live without the arts—nor would we want to.

For all these reasons and a thousand more, the arts have been an inseparable part of the human journey; indeed, we depend on the arts to carry us toward the fullness of our humanity. We value them for themselves, and because we do, we believe knowing and practicing them is fundamental to the healthy development of our children's minds and spirits. That is why, in any civilization—ours included—the arts are inseparable from the very meaning of the term "education." We know from long experience that *no one can claim to be truly educated who lacks basic knowledge and skills in the arts.*

If our civilization is to continue to be both dynamic and nurturing, its success will ultimately depend on how well we develop the capacities of our children, not only to earn a living in a vastly complex world, but to live a life rich in meaning. The vision this document holds out affirms that a future worth having depends on being able to construct a vital relationship with the arts, and that doing so, as with any other subject, is a matter of discipline and study.

Standards identify what our children must *know* and be able to *do*. Thus, the vision embedded in these Standards insists that a mere nodding acquaintance with the arts is not enough to sustain our children's interest or involvement in them. The Standards must usher each new generation onto the pathway of engagement, which opens in turn onto a lifetime of learning and growth through the arts. It is along this pathway that our children will find their personal directions and make their singular contributions. It is along this pathway, as well, that they will discover who they are, and even more, who they can become.

What Benefits Does an Arts Education Provide?

These Standards are an attempt to render, in operational terms, the value and importance of the arts for the educational well-being of our young people and our country. Arts education benefits both student and society. It benefits the *student* because it cultivates the whole child, gradually building many kinds of literacy while developing intuition, reasoning, imagination, and dexterity into unique forms of expression and communication. This process requires not merely an active mind but a trained one. Arts education also helps students by initiating them into a variety of ways of perceiving and thinking. Because so much of a child's education in the early years is devoted to acquiring the skills of language and mathematics, children gradually learn, unconsciously, that the "normal" way to think is linear and sequential, that the pathway to understanding moves from beginning to end, from cause to effect. In this dominant early mode, students soon learn to trust mainly those symbol systems, usually in the form of words, numbers, and abstract concepts, that separate the experiencing person from what that person experiences.

But the arts teach a different lesson. They sometimes travel along a road that moves in a direction similar to the one described above, but more often they start from a different place. The arts cultivate the direct experience of the senses; they trust the unmediated flash of insight as a legitimate source of knowledge. Their goal is to connect person and experience directly, to build the bridge between verbal and nonverbal, between the strictly logical and the emotional—the better to gain an understanding of the whole. Both approaches are powerful and both are necessary; to deny students either is to disable them.

An education in the arts also benefits *society* because students of the arts disciplines gain powerful tools for:

▲ understanding human experiences, both past and present;

▲ learning to adapt to and respect others' (often very different) ways of thinking, working, and expressing themselves;

▲ learning artistic modes of problem solving, which bring an array of expressive, analytical, and developmental tools to every human situation (this is why we speak, for example, of the "art" of teaching or the "art" of politics);

▲ understanding the influences of the arts, for example, in their power to create and reflect cultures, in the impact of design on virtually all we use in daily life, and in the interdependence of work in the arts with the broader worlds of ideas and action;

▲ making decisions in situations where there are no standard answers;

▲ analyzing nonverbal communication and making informed judgments about cultural products and issues; and

▲ communicating their thoughts and feelings in a variety of modes, giving them a vastly more powerful repertoire of self-expression.

In a world inundated with a bewildering array of messages and meanings, an arts education also helps young people explore, understand, accept, and use ambiguity and subjectivity. In art as in life, there is often no clear or "right" answer to questions that are nonetheless worth pursuing ("Should the trees in this painting be a little darker shade of green?"). At the same time, the arts bring excitement and exhilaration to the learning process. Study and competence reinforce each other; students become increasingly interested in learning, add new dimensions to what they already know, and enhance their expectations for learning even more. The joy of learning becomes real, tangible, powerful.

Perhaps most important, the arts have *intrinsic* value. They are worth learning for their own sake, providing benefits not available through any other means. To read Schiller's poem "Ode to Joy," for example, is to know one kind of beauty, yet to hear it sung by a great chorus as the majestic conclusion to Beethoven's Ninth Symphony is to experience beauty of an entirely different kind, an experience that for many is sublime. Because these experiences open up this transcending dimension of reality, there can be no substitute for an education in the arts, which provides bridges to things we can scarcely describe, but respond to deeply. In the simplest terms, no education is complete without them.

The arts also make a contribution to education that reaches beyond their intrinsic value. Because each arts discipline appeals to different senses and expresses itself through different media, each adds a special richness to the learning environment. An education in the arts helps students learn to identify, appreciate, and participate in the traditional art forms of their own communities. As students imagine, create, and reflect, they are developing both the verbal and nonverbal abilities necessary for school progress. At the same time, the intellectual demands that the arts place on students help them develop problem-solving abilities and such powerful thinking skills as analyzing, synthesizing, and evaluating. Further, numerous studies point toward a consistent and positive correlation between a substantive education in the arts and student achievement in other subjects and on standardized tests. A comprehensive, articulated arts education program also engages students in a process that helps them develop the self-esteem, self-discipline, cooperation, and self-motivation necessary for success in life.

An Education in the Arts Is for All Students

All students deserve access to the rich education and understanding that the arts provide, regardless of their background, talents, or disabilities. In an increasingly technological environment overloaded with sensory data, the ability to perceive, interpret, understand, and evaluate such stimuli is critical. The arts help all students to develop multiple capabilities for understanding and deciphering an image- and symbol-laden world. Thus, the arts should be an integral part of a program of general education for all students. In particular, students with disabilities, who are often excluded from arts programs, can derive great benefit from them—and for the same reasons

that studying the arts benefits students who are not disabled. As many teachers can testify, the arts can be a powerful vehicle—sometimes the best vehicle—for reaching, motivating, and teaching a given student. At the same time, there is a continuing need to make sure that all students have access to the learning resources and opportunities they need to succeed. Thus, as in any area of the curriculum, providing a sound education in the arts will depend in great measure on creating access to opportunities and resources.

In this context, the idea that an education in the arts is just for "the talented," and not for "regular students" or those with disabilities, can be a stumbling block. The argument that relegates the arts to the realm of passive experience for the majority, or that says a lack of "real talent" disqualifies most people from learning to draw, play an instrument, dance, or act, is simply wrong-headed. Clearly, students have different aptitudes and abilities in the arts, but differences are not disqualifications. An analogy may be helpful. We expect mathematical competence of all students because a knowledge of mathematics is essential to shaping and advancing our society, economy, and civilization. Yet no one ever advances the proposition that only those who are mathematically "talented" enough to earn a living as mathematicians should study long division or algebra. Neither, then, should talent be a factor in determining the place or value of the arts in an individual's basic education.

The Arts Are Important to Life and Learning

If arts education is to serve its proper function, each student must develop an understanding of such questions as these: What are the arts? How do artists work and what tools do they use? How do traditional, popular, and classical art forms influence one another? Why are the arts important to me and my society? As students seek the answers to these questions, they develop an understanding of the essence of each arts discipline, and of the knowledge and skills that enliven it. The content and the interrelatedness of the Standards, especially, go a long way toward producing such understanding. But meeting the Standards cannot—and should not—imply that every student will acquire a common set of artistic values. Ultimately, students are responsible for their own values. What the Standards *can* do is provide a positive and substantive framework for those who teach young people why and how the arts are valuable to them as persons and as participants in a shared culture.

The affirmations below describe the values that can inform what happens when the Standards, students, and their teachers come together. These expectations draw connections among the arts, the lives of students, and the world at large:

▲ The arts have both intrinsic and instrumental value; that is, they have worth in and of themselves and can also be used to achieve a multitude of purposes (e.g., to present issues and ideas, to teach or persuade, to entertain, to design, plan, and beautify).

▲ The arts play a valued role in creating cultures and building civilizations. Although each arts discipline makes its unique contributions to culture, society, and the lives of individuals, their connections to each other enable the arts disciplines to produce more than any of them could produce alone.

▲ The arts are a way of knowing. Students grow in their ability to apprehend their world when they learn the arts. As they create dances, music, theatrical productions, and visual artworks,

they learn how to express themselves and how to communicate with others.

▲ The arts have value and significance for daily life. They provide personal fulfillment, whether in vocational settings, avocational pursuits, or leisure.

▲ Lifelong participation in the arts is a valuable part of a life fully lived and should be cultivated.

▲ Appreciating the arts means understanding the interactions among the various professions and roles involved in creating, performing, studying, teaching, presenting, and supporting the arts, and in appreciating their interdependent nature.

▲ Awakening to folk arts and their influence on other arts deepens respect for one's own and for others' communities.

▲ Openness, respect for work, and contemplation when participating in the arts as an observer or audience member are personal attitudes that enhance enjoyment and ought to be developed.

▲ The arts are indispensable to freedom of inquiry and expression.

▲ Because the arts offer the continuing challenge of situations in which there is no standard or approved answer, those who study the arts become acquainted with many perspectives on the meaning of "value."

▲ The modes of thinking and methods of the arts disciplines can be used to illuminate situations in other disciplines that require creative solutions.

▲ Attributes such as self-discipline, the collaborative spirit, and perseverance, which are so necessary to the arts, can transfer to the rest of life.

▲ The arts provide forms of nonverbal communication that can strengthen the presentation of ideas and emotions.

▲ Each person has a responsibility for advancing civilization itself. The arts encourage taking this responsibility and provide skills and perspectives for doing so.

As students work at increasing their understanding of such promises and challenges presented by the arts, they are preparing to make their own contributions to the nation's storehouse of culture. The more students live up to these high expectations, the more empowered our citizenry will become. Indeed, helping students to meet these Standards is among the best possible investments in the future of not only our children, but also of our country and civilization.

The Difference Standards Make

Arts education standards can make a difference because, in the end, they speak powerfully to two fundamental issues that pervade all of education—quality and accountability. They help ensure that the study of the arts is disciplined and well focused, and that arts instruction has a

point of reference for assessing its results. In addressing these issues, the Standards insist on the following:

▲ That an arts education is not a hit-or-miss effort but a sequenced and comprehensive enterprise of learning across four arts disciplines, thus ensuring that basic arts literacy is a consequence of education in the United States;

▲ That instruction in the arts takes a hands-on orientation (i.e., that students be continually involved in the work, practice, and study required for effective and creative engagement in all four arts disciplines);

▲ That students learn about the diverse cultural and historical heritages of the arts. The focus of these Standards is on the global and the universal, not the localized and the particular;

▲ That arts education can lead to interdisciplinary study; achieving standards involves authentic connections among and across the arts and other disciplines;

▲ That the transforming power of technology is a force not only in the economy but in the arts as well. The arts teach relationships between the use of essential technical means and the achievement of desired ends. The intellectual methods of the arts are precisely those used to transform scientific discovery into technology;

▲ That across the board and as a pedagogical focus, the development of the problem-solving and higher-order thinking skills necessary for success in life and work is taken seriously; and

▲ That taken together, these Standards offer, for the first time in American arts education, a foundation for educational assessment on a student-by-student basis.

These features of the Standards will advance both quality and accountability to the levels that students, schools, and taxpayers deserve. They will help our nation compete in a world where the ability to produce continuing streams of creative solutions has become the key to success.

One by-product of adopting these Standards may be as revolutionary as it is exciting. Having the Standards in place may mean that teachers and others will be able to spend less time defending and advocating arts education and more time educating children, turning them toward the enriching power, the intellectual excitement, and the joy of competence in the arts.

Success in achieving these Standards will mean something else. As we look ahead, it is important to keep two things in mind. To the degree that students are successful in achieving them, the Standards will have to be raised to encourage higher expectations. At the same time, even though the substance of each of the arts disciplines will remain basically constant, the changes created by technology, new cultural trends, and educational advances will necessitate changes in the Standards as well. Among the educational changes likely to affect the structure of these Standards, for example, are those that may rearrange the school day and year, or the prospect that progression by grade level may give way to mastery as the overriding goal of education.

Arts Standards Are at the Core of Education Reform

With the passage of the *Goals 2000: Educate America Act,* the arts are written into federal law. The law acknowledges that the arts are a core subject, as important to education as English, mathematics, history, civics and government, geography, science, and foreign language. Title II of the Act addresses the issue of education standards. It establishes a National Education Standards Improvement Council, which has, among its other responsibilities, the job of working with appropriate organizations to determine the criteria for certifying *voluntary content standards,* with three objectives in mind: (1) to ensure that the standards are internationally competitive, (2) to ensure they reflect the best knowledge about teaching and learning, and (3) to ensure they have been developed through a broad-based, open adoption process.

In 1992, in anticipation of education standards emerging as a focal point of the reform legislation, the Consortium of National Arts Education Associations successfully approached the U.S. Department of Education, the National Endowment for the Arts, and the National Endowment for the Humanities, for a grant to determine what the nation's school children should know and be able to do in the arts.

This document is thus the result of an extended process of consensus-building that has included a variety of efforts designed to secure the broadest possible range of expertise and reaction. The process involved the review of state-level arts education frameworks, standards from other nations, a succession of drafts by the arts education community, as well as consideration at a series of national forums where comment and testimony were received.

The Standards Provide a Crucial Foundation

The arts have emerged from the education reform movement of the last decade as a vital partner in the continuing effort to provide our children with a world-class education. The Standards are a crucial element in that enterprise.

Almost alone in the industrialized world, the United States has no national curriculum. But national standards approach the task of education from a different angle; they speak of competencies, not a predetermined course of study. The need for standards arises, in part, from the recognition that we Americans can never know how well our schools are doing without some coherent sense of results. We recognize an obligation to provide our children with the knowledge and skills that will equip them to enter society, work productively, and make their contributions as citizens. In short, we need the clarity and conviction to say, *"This is what a student should know and be able to do."* At the same time, in spite of our disparateness, Americans understand that, at the core, we are *one* country. As the education reform movement has recognized from the beginning, we need national goals—statements of desired results—to provide a broad framework for state and local decision making.

But the most important contribution that standards-setting makes lies in the process itself. In setting them forth, we are inevitably forced to think through what we believe—and why. The process refreshes and renews our interest in and commitment to education in general, and to what we believe is important in all subjects.

Standards for arts education are important for two fundamental reasons. First, they help define what a good education in the arts should provide: a thorough grounding in a basic body of knowledge and the skills required both to make sense and to make use of each of the arts disciplines—including the intellectual tools to make qualitative judgments about artistic products and expression. Second, when states and school districts adopt the standards, they are taking a stand for rigor, informed by a clear intent. A set of standards for arts education says, in effect, "An education in the arts means that students should know what is spelled out here, reach specified levels of attainment, and do both at defined points in their education." Put differently, arts standards provide a vision of both competence and educational effectiveness, but without creating a mold into which all arts programs must fit. Let us be clear. These Standards are concerned with which *results,* in the form of student learning, are characteristic of a basic education in the arts, but *not with how those results ought to be delivered.* The Standards do not provide a course of study, but they can help weak arts instruction and programs improve and help make good programs even better.

The arts Standards are deliberately broad statements, the better to encourage local curricular objectives and flexibility in classroom instruction, that is, to draw on local resources and to meet local needs. These Standards also present areas of content, expectations for student experience, and levels of student achievement, but without endorsing any particular philosophy of education, specific teaching methods, or aesthetic points of view. The latter are matters for states, localities, and classroom teachers.

The Standards Are Keys to Each of the Arts Disciplines

Each of the arts disciplines is in itself a vast body of subject matter—an array of skills, knowledge, and techniques offering the student a means of communication and modes of thought and action. Each discipline also provides rich and complex points of view on the world and human experience. Each offers analytical and theoretical perspectives, a distinct history, many schools of interpretation, as well as innumerable connections to all human activity. Amid this wealth, the Standards offer basic points of entry into the study of the arts disciplines.

When a standard for any given arts discipline has been met or achieved by the student, it means that a door has been opened; the student can use his or her achievement as a point of departure for other destinations. To take a straightforward example from dance, when a child learns to use basic movements to create and vary a movement theme, a new possibility is created. Now the child knows what it means to convert a rhythm heard with the ear into one that is expressed by the body. The child who reaches this point has not merely met a standard, but has learned a "new grammar"—one based on physical movement. As students grow in competence, their learning thus resembles an ascent up a spiral staircase; at each level, a new door opens onto an experience that is more challenging and more rewarding. The Standards are meant to reinforce this continual dynamic of climbing and exploring, a process that leads to increasing competence. As students meet these Standards, they learn to choose intelligently among many approaches that are likely to lead to the solution of an artistic or intellectual problem. Indeed, creative thinking cannot occur without this ability to choose.

But the Standards, rooted in the individual integrity of the visual arts, dance, music, and theatre, are more than doors to new capabilities and discoveries. They also serve as the foundation for making connections among the arts and to other areas of the curriculum.

The Standards Are Keys to Correlation and Integration

A basic intent of the Standards is that the arts be taught for their intrinsic value. Beyond their significance in this arena, however, one of the most important goals the Standards can achieve is to help students make connections between concepts and across subjects. To this end, the Standards for each arts discipline reflect different kinds of learning tasks. By addressing these tasks together, students can fully explore each of the specific arts disciplines in and of itself. They can use these same tasks as bridges among the arts disciplines, and finally as gateways from the arts to other areas of study. But the Standards do not create these connections automatically, simply by their existence; making the connections is always a matter of *instruction*.

Connections among the arts or between the arts and other subjects are fundamentally of two kinds, which should not be confused. *Correlations* show specific similarities or differences. A simple example is the correlation between music and mathematics. Clearly evident in the structure of both are such elements as counting, intervals, and consistent numerical values. More complex examples could involve studies based on such areas as aesthetics, sociology, or historic periods, in which texts, interpretations, and analyses about two or more art forms are compared and contrasted. *Integration* is different from correlation. Instead of placing different subjects side by side to compare or contrast them, integration uses the resources of two or more disciplines in ways that are mutually reinforcing, often demonstrating an underlying unity. A simple example of integration within the arts is using combinations of visual effects and words to create a dramatic mood. At a more complex level involving the study of history, other examples of integration might be how the American theatre in the period 1900–1975 reflected shifts in the American social consciousness, or how the sacred and secular music of African-Americans contributed to the civil rights movement.

Because forging these kinds of connections is one of the things the arts do best, they can and should be taught in ways that connect them both to each other and to other subjects. Significantly, building connections in this way gives students the chance to understand wholes, parts, and their relationships. The high school student of world history who has learned something about the visual arts of Japan will understand the politics of the Tokugawa shoguns far better than a classmate who knows nothing of how the art of Japan reflects that country's core values. But one point is basic. Correlation, integration, and similar approaches to learning are first of all a matter of knowledge and competence within each of the arts disciplines themselves, which must be maintained in their full integrity. This competence is what the Standards address most powerfully.

The Standards Incorporate Cultural Diversity

The culture of the United States is a rich mix of people and perspectives, drawn from many cultures, traditions, and backgrounds. That diversity provides American students with a distinctive learning advantage: they can juxtapose unique elements of their individual cultural traditions with elements that have been embraced, incorporated, and transformed into a shared culture. In the process, they learn that diverse heritages are accessible to all.

The cultural diversity of America is a vast resource for arts education, and should be used to help students understand themselves and others. The visual, traditional, and performing arts provide a variety of lenses for examining the cultures and artistic contributions of our nation and others around the world. Students should learn that each art form has its own characteristics and makes its distinctive contributions, that each has its own history and heroes. Students need to

13

learn the profound connections that bind the arts to one another, as well as the connections between particular artistic styles and the historical development of the world's cultures. Students also need to understand that art is a powerful force in the everyday life of people around the world, who design and make many of the objects they use and enjoy. It is therefore essential that those who construct arts curricula attend to issues of ethnicity, national custom, tradition, religion, and gender, as well as to the artistic elements and aesthetic responses that transcend and universalize such particulars. The polyrhythmic choreography of Native American dancing, the incomparable vocal artistry of a Jessye Norman, the sensitive acting of an Edward James Olmos, and the intricate calligraphy of Japanese and Arabic artists are, after all, more than simply cultural artifacts; they are part of the world's treasure house of expression and understanding. As such, they belong to every human being.

The Standards regard these considerations of time, place, and heritage as basic to developing curriculum. Subject matter from diverse historical periods, styles, forms, and cultures should be used to develop basic knowledge and skills in the various arts disciplines.

The Standards Focus on Appropriate Technologies

The arts disciplines, their techniques, and their technologies have a strong historic relationship; each continues to shape and inspire the other. Existing and emerging technologies will always be a part of how changes in the arts disciplines are created, viewed, and taught. Examples abound. In ancient times, sculptors used hardened metals to chisel wood and marble blocks; today they use acetylene torches to work in metal itself. The modern ballet slipper was a technological advance that emerged in the late nineteenth century; today it is complemented by the dancer's use of variable-resistance exercise equipment. Stradivarius once used simple charcoal and paper to design his violins; today's manufacturers use computers to design electronic instruments. The theatre, once limited to the bare stage, has found important resources for creating dramatic productions in such technologies as radio, film, television, and other electronic media.

For the arts, technology thus offers means to accomplish artistic, scholarly, production, and performance goals. But the mere availability of technology cannot ensure a specific artistic result: the pencil in a student's hand ensures neither drawing competency nor a competent drawing. Nor, by itself, will exchanging the pencil for an airbrush or a computer graphics program create a change in the student. What can happen is that interesting and engaging technologies can attract and motivate students to engage the arts. In the end, however, the use of technology in arts instruction is meaningful only to the degree that it contributes to competence, and that contribution comes through instruction and study. Used appropriately, technology can extend the reach of both the art form and that of the learner.

These considerations are especially important because of technology's power to expand today's students' access to information, opportunities, and choices. New technologies make it possible to try out a host of possibilities and solutions, and expanding learning technologies make it more important than ever that these tools be used to teach the arts. Computers create unimaginable efficiencies and opportunities for experimentation, and do it instantly. If well used, interactive video can also have a significant impact on the development of creative thinking skills. The educational challenge is to make sure that as technology expands the array of choices, students are also well guided toward choosing, compiling, and arranging materials appropriate to specific artistic ends.

The Standards should be considered as a catalyst for bringing the best arts-related technologies

to bear on arts education. We need to remember, however, that access to many technologies will necessarily vary. The Standards are not themselves dependent on any particular technology; they can be met using a variety of technologies on different levels. The working assumption of the Standards is that whatever technology is available will be used not for its own sake, but to promote learning in the arts and the achievement of the Standards. Success should be thus measured by how well students achieve artistic and intellectual objectives, not alone by how adept they are in using a given arts technology. The use of technology should increase their ability to synthesize, integrate, and construct new meanings from a wealth of new resources and information. The effective results should be that students come to understand the relationships among technical means, artistic technique, and artistic end.

The Standards Provide a Foundation for Student Assessment

Because arts education places a high value on personal insight, individual achievement, and group performance, educators must be able to assess these things; otherwise, it will be impossible to know whether the Standards are being reached. Because the Standards are consensus statements about what an education in the arts should contain, they can provide a basis for student assessment, and for evaluating programs, at national, state, and local levels. A broad range of measures could well be used to assess whether a given standard is being met. As in any area of the curriculum, tests and other measures used in assessing students in the arts should be statistically valid and reliable, as well as sensitive to the student's learning context.

One of the substantial advantages offered by this comprehensive set of arts standards is that they combat the uninformed idea that the arts are an "academically soft" area of study. People unfamiliar with the arts often mistakenly believe that excellence and quality are merely matters of opinion ("I know what I like"), and that one opinion is as good as another. The Standards say that the arts have "academic" standing. They say there is such a thing as achievement, that knowledge and skills matter, and that mere willing participation is not the same thing as education. They affirm that discipline and rigor are the road to achievement. And they state emphatically that all these things can in some way be measured—if not always on a numerical scale, then by informed critical judgment.

Arts educators can take pride in the fact that other content areas have borrowed heavily from assessment techniques long used in the arts, e.g., the practice of portfolio review in the visual arts and the assessment of performance skills through the auditions used in dance, music, and theatre. It is worth noting that the content of these *Standards* informs the perspective of the National Assessment of Educational Progress, which attends to "creating, performing, and responding" in the arts. Although some aspects of learning in the arts can be measured adequately by traditional paper-and-pencil techniques or demonstrations, many skills and abilities can be properly assessed only by using subtle, complex, and nuanced methods and criteria that require a sophisticated understanding. Assessment measures should incorporate these subtleties, while at the same time making use of a broad range of performance tasks.

The Standards Point Beyond Mere "Exposure"

All basic subjects, including the arts, require more than mere "exposure" or access. They need focused time for sequential study, practice, and reflection. While valuable, a once-a-month visit from an arts specialist, visits to or from professional artists, or arts courses for the specially motivated do not qualify as basic or adequate arts instruction. They certainly cannot prepare all stu-

dents to meet the Standards presented here. These Standards assume that students in all grades will be actively involved in comprehensive, sequential programs that include creating, performing, and producing on the one hand, and study, analysis, and reflection on the other. Both kinds of activities are indispensable elements of a well-rounded education in the arts.

The comprehensive nature of these Standards does not require an inordinate focus on the arts at the expense of other subjects. Leading groups of arts educators, as well as the National Endowment for the Arts, recommend that 15 percent of instructional time at the elementary and middle school levels be devoted to serious study of the arts. In high school, it is expected that achieving the basic competencies set forth here will mean arts *requirements,* not just electives.

By the same token, however, when children move beyond the "exposure" level toward proficiency in an arts discipline, the basic processes of creating, performing, producing, thinking, perceiving, and responding in one context become available to them in another. The child who learns how to read or cipher can conquer new worlds with those basic skills. Just so, the child who learns to see with an artist's eye, hear with the musician's ear, dramatize the playwright's vision, or tell a story with the body's movement has acquired a tool that can enrich and enliven all learning, whether in the other arts or beyond them.

The creative and continual use of community resources is an important element in making sure that students receive more than exposure to the arts. Local orchestras and choruses, theatre groups and dance companies, individual professional artists, galleries, museums, concerts, and other kinds of performances all offer a rich repertoire of arts experiences that the schools can seldom match. State and local arts agencies and arts councils, as well as local chapters of national arts and arts education organizations, all have a rich contribution to make. All can offer distinctive introductions to the wealth of possibilities in the arts and serve as sources of profound learning. Teachers, education administrators, parents, and local arts organizations can create not merely "arts events" but working partnerships specifically designed to sustain, expand, and deepen students' competence in all the arts disciplines.

Adopting the Standards Is Only a Beginning

Our way of life in the modern world and the success of our children in it depend on creating a society that is both literate and imaginative, competent and creative. In a world exploding with information and experience, in which media saturate our culture with powerful images and messages at every turn, it is critical that young people be provided with tools not only for understanding that world, but also for contributing to it and making their own way. Without the arts to help shape students' perceptions and imaginations, young people stand every chance of growing into adulthood as culturally disabled. We must not allow that to happen.

If our young people are to be fully educated, they need instructional programs in the arts that accurately reflect and faithfully transmit the pluralistic purposes, skills, and experiences that are unique to the arts—a heritage that also deeply enriches general education. What happens in the schools will require the active support of arts organizations, trade and professional groups in the arts, educational organizations, performers, and working artists. Without question, the Standards presented here will need supporters and allies in improving and changing how arts education is organized and delivered. But they themselves contain the potential to act as a lever on public perception and teacher preparation as well, to change education policy at all levels, and to make a transforming impact across the entire spectrum of education.

But only if they are implemented.

Developing the physical and mental abilities needed to learn any art form can occur only through personal interaction with subject matter, the mastery of tools, adapting to physical challenges, and sustained relationships with others who have also subjected themselves to the discipline the arts require.

Teachers encourage and lead this interactive process. Since it is impossible to teach what one does not know, bringing the Standards to life in students will require professional development for many teachers and changes in teacher preparation programs. In many places, more teachers with credentials in the arts will be needed. Preservice training will have to be restructured to include the arts, or an existing arts training component will have to be strengthened. Many teachers already in service will need to supplement their knowledge and skills, acquire new capabilities, and form teaching alliances with arts specialists. Doing so will not be easy, but doing so is as necessary as it is worthwhile.

Site-based management teams, school boards, state education agencies, state and local arts agencies, teacher education institutions, and local programs of in-service education all bear a responsibility here, as do instructional approaches that involve the use of mentors, local artists, and members of the community. The support of such people and groups is crucial for the Standards to succeed. But the primary issue is the competence to bring together and deliver a broad range of competent instruction. All else is secondary.

Having written a set of voluntary Standards is only a first step. Merely "adopting" them will not be enough to make them effective, nor will changing the official expectations for student performance suffice to change the performance itself. New policy will be necessary. New and reallocated resources will be required. Teacher preparation and professional development must keep pace. People who care about the arts and arts education will have to commit themselves to a broad, cooperative, and, indeed, relentless effort if implementation is to be successful.

In the end, truly successful implementation can come about only when students and their learning are at the center, which means motivating and enabling them to meet the Standards. With a steady gaze on that target, these Standards can empower America's schools to make changes consistent with the best any of us can envision for our children and for our society.

The Standards

How the Standards Are Organized

Teachers, policymakers, and students all need explicit statements of the results expected from an arts education, not only for pedagogical reasons, but to be able to allocate instructional resources and to provide a basis for assessing student achievement and progress. Because the largest groups using the Standards will be teachers and educational administrators, the most sensible sequence for presenting the Standards is by grade level: Grades K–4, Grades 5–8, and Grades 9–12. Individual standards should be understood as a statement of what students should know and be able to do. They may, of course, acquire the competency at any time within the specified period, but they will be expected to have acquired it before they move on.

Within each grade-level cluster, the Standards are organized by arts discipline: **Dance, Music, Theatre,** and **Visual Arts.** Presented within each of the disciplines are the specific *competencies*

that the arts education community, nationwide, believes are essential for every student. Although the statement of any specific competency in any of the arts disciplines necessarily focuses on one part of that discipline, the Standards stress that all the competencies are interdependent.

The division of the Standards into special competencies does not indicate that each is—or should be—given the same weight, time, or emphasis at any point in the K–12 sequence, or over the student's entire school career. The mixture and balance will vary with grade level, by course, by instructional unit, and from school to school.

The Standards encourage a relationship between breadth and depth so that neither overshadows the other. They are intended to create a vision for learning, not a standardized instructional system.

Two different types of standards are used to guide student assessment in each of the competence areas:

▲ *Content standards* specify what students should know and be able to do in the arts disciplines.

▲ *Achievement standards* specify the understandings and levels of achievement that students are expected to attain in the competencies, for each of the arts, at the completion of grades 4, 8, and 12.

In this document, a number of achievement standards are described for each content standard. In grades 9–12, two levels of achievement standards—"Proficient" and "Advanced"—are offered for each of the arts disciplines. Several standards may be offered in each of these two categories. In grades 9–12, the "Advanced" level of achievement is more likely to be attained by students who have elected specialized courses in the particular arts discipline than by students who have not. All students, however, are expected to achieve at the "Proficient" level in at least one art.

What Students Should Know and Be Able to Do in the Arts

There are many routes to competence in the arts disciplines. Students may work in different arts at different times. Their study may take a variety of approaches. Their abilities may develop at different rates. Competence means the ability to use an array of knowledge and skills. Terms often used to describe these include creation, performance, production, history, culture, perception, analysis, criticism, aesthetics, technology, and appreciation. Competence means capabilities with these elements themselves and an understanding of their interdependence; it also means the ability to combine the content, perspectives, and techniques associated with the various elements to achieve specific artistic and analytical goals. Students work toward comprehensive competence from the very beginning, preparing in the lower grades for deeper and more rigorous work each succeeding year. As a result, the joy of experiencing the arts is enriched and matured by the discipline of learning and the pride of accomplishment. Essentially, the Standards ask that students should know and be able to do the following by the time they have completed secondary school:

▲ *They should be able to communicate at a basic level in the four arts disciplines*—dance, music, theatre, and the visual arts. This includes knowledge and skills in the use of the basic vocabularies, materials, tools, techniques, and intellectual methods of each arts discipline.

▲ *They should be able to communicate proficiently in at least one art form,* including the ability to

define and solve artistic problems with insight, reason, and technical proficiency.

▲ *They should be able to develop and present basic analyses of works of art* from structural, historical, and cultural perspectives, and from combinations of those perspectives. This includes the ability to understand and evaluate work in the various arts disciplines.

▲ *They should have an informed acquaintance with exemplary works of art from a variety of cultures and historical periods,* and a basic understanding of historical development in the arts disciplines, across the arts as a whole, and within cultures.

▲ *They should be able to relate various types of arts knowledge and skills within and across the arts disciplines.* This includes mixing and matching competencies and understandings in art-making, history and culture, and analysis in any arts-related project.

As a result of developing these capabilities, students can arrive at their own knowledge, beliefs, and values for making personal and artistic decisions. In other terms, they can arrive at a broad-based, well-grounded understanding of the nature, value, and meaning of the arts as a part of their own humanity.

STANDARDS IN THE ARTS

GRADES K-4

The standards in this section describe the cumulative skills and knowledge expected of all students upon exiting grade 4. Students in the earlier grades should engage in developmentally appropriate learning experiences designed to prepare them to achieve these standards at grade 4. Determining the curriculum and the specific instructional activities necessary to achieve the standards is the responsibility of states, local school districts, and individual teachers.

Terms identified by an asterisk (*) are explained in the glossary.

Dance

Children in grades K–4 love to move and learn through engagement of the whole self. They need to become literate in the language of dance in order to use this natural facility as a means of communication and self-expression, and as a way of responding to the expression of others. Dancing and creating dances provide them with skills and knowledge necessary for all future learning in dance and give them a way to celebrate their humanity.

Dance education begins with an awareness of the movement of the body and its creative potential. At this level, students become engaged in body awareness and movement exploration that promote a recognition and appreciation of self and others. Students learn basic movement and *choreographic skills in musical/rhythmic contexts. The skills and knowledge acquired allow them to begin working independently and with a partner in creating and performing dances.

Experiences in perceiving and responding to dance expand students' vocabularies, enhance their listening and viewing skills, and enable them to begin thinking critically about dance. They investigate questions such as "What is it? How does it work? Why is it important?" Practicing attentive audience behavior for their peers leads to describing movement *elements and identifying expressive movement choices. Students learn to compare works in terms of the elements of space, time, and force/energy and to experience the similarities and differences between dance and other disciplines.

Through dance education, students can also come to an understanding of their own culture and begin to respect dance as a part of the heritage of many cultures. As they learn and share dances from around the globe, as well as from their own communities, children gain skills and knowledge that will help them participate in a diverse society.

23

1. Content Standard: Identifying and demonstrating movement elements and skills in performing dance

Achievement Standard:

Students

 a. accurately demonstrate nonlocomotor/*axial movements (such as bend, twist, stretch, swing)
 b. accurately demonstrate eight basic *locomotor movements (such as walk, run, hop, jump, leap, gallop, slide, and skip), traveling forward, backward, sideward, diagonally, and turning
 c. create shapes at low, middle, and high *levels
 d. demonstrate the ability to define and maintain *personal space
 e. demonstrate movements in straight and curved pathways
 f. demonstrate accuracy in moving to a musical beat and responding to changes in tempo
 g. demonstrate *kinesthetic awareness, concentration, and focus in performing movement skills
 h. attentively observe and accurately describe the *action (such as skip, gallop) and movement elements (such as *levels, directions) in a brief movement study

2. Content Standard: Understanding choreographic principles, processes, and structures

Achievement Standard:

Students

 a. create a sequence with a beginning, middle, and end, both with and without a rhythmic accompaniment; identify each of these parts of the sequence

 b. improvise, create, and perform dances based on their own ideas and concepts from other sources

 c. use *improvisation to discover and invent movement and to solve movement problems

 d. create a dance *phrase, accurately repeat it, and then vary it (making changes in the time, space, and/or force/energy)

 e. demonstrate the ability to work effectively alone and with a partner

 f. demonstrate the following partner skills: copying, leading and following, mirroring

3. Content Standard: Understanding dance as a way to create and communicate meaning

Achievement Standard:

Students

 a. observe and *discuss how dance is different from other forms of human movement (such as sports, everyday gestures)

 b. take an active role in a class discussion about interpretations of and reactions to a dance

 c. present their own dances to peers and discuss their meanings with competence and confidence

4. Content Standard: Applying and demonstrating critical and creative thinking skills in dance

Achievement Standard:

Students

 a. explore, discover, and realize multiple solutions to a given movement problem; choose their favorite solution and discuss the reasons for that choice

 b. observe two dances and discuss how they are similar and different in terms of one of the *elements of dance (such as space) by observing body shapes, levels, pathways

5. Content Standard: Demonstrating and understanding dance in various cultures and historical periods

Achievement Standard:

Students

 a. perform *folk dances from various cultures with competence and confidence

b. learn and effectively share a dance from a resource in their own community; describe the cultural and/or historical context

c. accurately answer questions about dance in a particular culture and time period (for example, In colonial America, why and in what settings did people dance? What did the dances look like?)

6. Content Standard: Making connections between dance and healthful living

Achievement Standard:

Students

a. identify at least three personal goals to improve themselves as dancers

b. explain how healthy practices (such as nutrition, safety) enhance their ability to dance, citing multiple examples

7. Content Standard: Making connections between dance and other disciplines

Achievement Standard:

Students

a. create a dance project that reveals understanding of a concept or idea from another discipline (such as pattern in dance and science)

b. respond to a dance using another art form; explain the connections between the dance and their response to it (such as stating how their paintings reflect the dance they saw)

Music

Performing, creating, and responding to music are the fundamental music processes in which humans engage. Students, particularly in grades K–4, learn by doing. Singing, playing instruments, moving to music, and creating music enable them to acquire musical skills and knowledge that can be developed in no other way. Learning to read and notate music gives them a skill with which to explore music independently and with others. Listening to, analyzing, and evaluating music are important building blocks of musical learning. Further, to participate fully in a diverse, global society, students must understand their own historical and cultural heritage and those of others within their communities and beyond. Because music is a basic expression of human culture, every student should have access to a balanced, comprehensive, and sequential program of study in music.

1. Content Standard: Singing, alone and with others, a varied repertoire of music

Achievement Standard:

Students

 a. sing independently, on pitch and in rhythm, with appropriate *timbre, diction, and posture, and maintain a steady tempo

 b. sing *expressively, with appropriate *dynamics, phrasing, and interpretation

 c. sing from memory a varied repertoire of songs representing *genres and *styles from diverse cultures

 d. sing *ostinatos, partner songs, and rounds

 e. sing in groups, blending vocal timbres, matching dynamic levels, and responding to the cues of a conductor

2. Content Standard: Performing on instruments, alone and with others, a varied repertoire of music

Achievement Standard:

Students

 a. perform on pitch, in rhythm, with appropriate dynamics and timbre, and maintain a steady tempo

 b. perform easy rhythmic, melodic, and chordal patterns accurately and independently on rhythmic, melodic, and harmonic *classroom instruments

 c. perform expressively a varied repertoire of music representing diverse genres and styles

 d. echo short rhythms and melodic patterns

 e. perform in groups, blending instrumental timbres, matching dynamic levels, and responding to the cues of a conductor

 f. perform independent instrumental parts[1] while other students sing or play contrasting parts

1. E.g., simple rhythmic or melodic ostinatos, contrasting rhythmic lines, harmonic progressions and chords

3. Content Standard: Improvising melodies, variations, and accompaniments

Achievement Standard:

Students

 a. improvise "answers" in the same style to given rhythmic and melodic phrases

 b. improvise simple rhythmic and melodic ostinato accompaniments

 c. improvise simple rhythmic variations and simple melodic embellishments on familiar melodies

 d. improvise short songs and instrumental pieces, using a variety of sound sources, including traditional sounds, nontraditional sounds available in the classroom, body sounds, and sounds produced by electronic means[2]

4. Content Standard: Composing and arranging music within specified guidelines

Achievement Standard:

Students

 a. create and arrange music to accompany readings or dramatizations

 b. create and arrange short songs and instrumental pieces within specified guidelines[3]

 c. use a variety of sound sources when composing

5. Content Standard: Reading and notating music

Achievement Standard:

Students

 a. read whole, half, dotted half, quarter, and eighth notes and rests in $\frac{2}{4}$, $\frac{3}{4}$, and $\frac{4}{4}$ *meter signatures

 b. use a system (that is, syllables, numbers, or letters) to read simple pitch notation in the treble clef in major keys

 c. identify symbols and traditional terms referring to dynamics, tempo, and *articulation and interpret them correctly when performing

 d. use standard symbols to notate *meter, rhythm, pitch, and dynamics in simple patterns presented by the teacher

2. E.g., traditional sounds: voices, instruments; nontraditional sounds: paper tearing, pencil tapping; body sounds: hands clapping, fingers snapping; sounds produced by electronic means: personal computers and basic *MIDI devices, including keyboards, sequencers, synthesizers, and drum machines

3. E.g., a particular style, form, instrumentation, compositional technique

6. Content Standard: Listening to, analyzing, and describing music

Achievement Standard:

Students

 a. identify simple music *forms when presented aurally

 b. demonstrate perceptual skills by moving, by answering questions about, and by describing aural examples of music of various styles representing diverse cultures

 c. use appropriate terminology in explaining music, music notation, music instruments and voices, and music performances

 d. identify the sounds of a variety of instruments, including many orchestra and band instruments, and instruments from various cultures, as well as children's voices and male and female adult voices

 e. respond through purposeful movement[4] to selected prominent music characteristics or to specific music events[5] while listening to music

7. Content Standard: Evaluating music and music performances

Achievement Standard:

Students

 a. devise criteria for evaluating performances and compositions

 b. explain, using appropriate music terminology, their personal preferences for specific musical works and styles

8. Content Standard: Understanding relationships between music, the other arts, and disciplines outside the arts

Achievement Standard:

Students

 a. identify similarities and differences in the meanings of common terms[6] used in the various arts

 b. identify ways in which the principles and subject matter of other disciplines taught in the school are interrelated with those of music[7]

4. E.g., swaying, skipping, dramatic play

5. E.g., meter changes, dynamic changes, same/different sections

6. E.g., form, line, contrast

7. E.g., foreign languages: singing songs in various languages; language arts: using the expressive elements of music in interpretive readings; mathematics: mathematical basis of values of notes, rests, and meter signatures; science: vibration of strings, drum heads, or air columns generating sounds used in music; geography: songs associated with various countries or regions

9. Content Standard: Understanding music in relation to history and culture

Achievement Standard:

Students

 a. identify by genre or style aural examples of music from various historical periods and cultures

 b. describe in simple terms how *elements of music are used in music examples from various cultures of the world

 c. identify various uses of music in their daily experiences and describe characteristics that make certain music suitable for each use

 d. identify and describe roles of musicians[8] in various music settings and cultures

 e. demonstrate audience behavior appropriate for the context and style of music performed

8. E.g., orchestra conductor, folksinger, church organist

Theatre

Theatre, the imagined and enacted world of human beings, is one of the primary ways children learn about life—about actions and consequences, about customs and beliefs, about others and themselves. They learn through their *social pretend play and from hours of viewing television and film. For instance, children use pretend play as a means of making sense of the world; they create situations to play and assume *roles; they interact with peers and arrange *environments to bring their stories to life; they direct one another to bring order to their *drama, and they respond to one another's dramas. In other words, children arrive at school with rudimentary skills as playwrights, actors, designers, directors, and audience members; theatre education should build on this solid foundation. These standards assume that theatre education will start with and have a strong emphasis on *improvisation, which is the basis of social pretend play.

In an effort to create a seamless transition from the natural skills of pretend play to the study of theatre, the standards call for instruction that integrates the several aspects of the art form: script writing, acting, designing, directing, researching, comparing art forms, analyzing and critiquing, and understanding contexts. In the kindergarten through fourth grade, the teacher will be actively involved in the students' planning, playing, and evaluating, but students will be guided to develop group skills so that more independence is possible. The content of the drama will develop the students' abilities to express their understanding of their immediate world and broaden their knowledge of other cultures.

1. Content Standard: Script writing by planning and recording improvisations based on personal experience and heritage, imagination, literature, and history

Achievement Standard:

Students

a. collaborate to select interrelated characters, environments, and situations for *classroom dramatizations

b. improvise dialogue to tell stories, and formalize improvisations by writing or recording the dialogue

2. Content Standard: Acting by assuming roles and interacting in improvisations

Achievement Standard:

Students

a. imagine and clearly describe characters, their relationships, and their environments

b. use variations of locomotor and nonlocomotor movement and vocal pitch, tempo, and tone for different characters

c. assume roles that exhibit concentration and contribute to the *action of classroom dramatizations based on personal experience and heritage, imagination, literature, and history

3. Content Standard: Designing by visualizing and arranging environments for classroom dramatizations

Achievement Standard:

Students

 a. visualize environments and construct designs to communicate locale and mood using visual elements (such as space, color, line, shape, texture) and aural aspects using a variety of sound sources

 b. collaborate to establish playing spaces for classroom dramatizations and to select and safely organize available materials that suggest scenery, properties, lighting, sound, costumes, and makeup

4. Content Standard: Directing by planning classroom dramatizations

Achievement Standard:

Students

 a. collaboratively plan and prepare improvisations and demonstrate various ways of staging classroom dramatizations

5. Content Standard: Researching by finding information to support classroom dramatizations

Achievement Standard:

Students

 a. communicate information to peers about people, events, time, and place related to classroom dramatizations

6. Content Standard: Comparing and connecting art forms by describing theatre, dramatic media (such as film, television, and *electronic media), and other art forms

Achievement Standard:

Students

 a. describe visual, aural, oral, and kinetic elements in theatre, dramatic media, dance, music, and visual arts

 b. compare how ideas and emotions are expressed in theatre, dramatic media, dance, music, and visual arts

 c. select movement, music, or visual elements to enhance the mood of a classroom dramatization

7. Content Standard: Analyzing and explaining personal preferences and *constructing meanings from classroom dramatizations and from theatre, film, television, and electronic media productions

Achievement Standard:

Students

 a. identify and describe the visual, aural, oral, and kinetic elements of classroom dramatizations and dramatic performances
 b. explain how the wants and needs of characters are similar to and different from their own
 c. articulate emotional responses to and explain personal preferences about the whole as well as the parts of dramatic performances
 d. analyze classroom dramatizations and, using appropriate terminology, constructively suggest alternative ideas for dramatizing roles, arranging environments, and developing situations along with means of improving the collaborative processes of planning, playing, responding, and evaluating

8. Content Standard: Understanding context by recognizing the role of theatre, film, television, and electronic media in daily life

Achievement Standard:

Students

 a. identify and compare similar characters and situations in stories and dramas from and about various cultures, illustrate with classroom dramatizations, and discuss how theatre reflects life
 b. identify and compare the various settings and reasons for creating dramas and attending theatre, film, television, and electronic media productions

Visual Arts

These standards provide a framework for helping students learn the characteristics of the *visual arts by using a wide range of subject matter, symbols, meaningful images, and visual *expressions, to reflect their *ideas, feelings, and emotions; and to evaluate the merits of their efforts. The standards address these objectives in ways that promote acquisition of and fluency in new ways of thinking, working, communicating, reasoning, and investigating. They emphasize student acquisition of the most important and enduring *ideas, concepts, issues, dilemmas, and knowledge offered by the visual arts. They develop new *techniques, approaches, and habits for applying knowledge and skills in the visual arts to the world beyond school.

The visual arts are extremely rich. They range from drawing, painting, sculpture, and design, to architecture, film, video, and folk arts. They involve a wide variety of *tools, techniques, and processes. The standards are structured to recognize that many elements from this broad array can be used to accomplish specific educational objectives. For example, drawing can be used as the basis for creative activity, historical and cultural investigation, or *analysis, as can any other fields within the visual arts. The standards present educational goals. It is the responsibility of practitioners to choose appropriately from this rich array of content and processes to fulfill these goals in specific circumstances and to develop the curriculum.

To meet the standards, students must learn vocabularies and concepts associated with various types of work in the visual arts and must exhibit their competence at various levels in visual, oral, and written form.

In Kindergarten–Grade 4, young children experiment enthusiastically with *art materials and investigate the ideas presented to them through visual arts instruction. They exhibit a sense of joy and excitement as they make and share their artwork with others. Creation is at the heart of this instruction. Students learn to work with various tools, processes, and *media. They learn to coordinate their hands and minds in explorations of the visual world. They learn to make choices that enhance communication of their ideas. Their natural inquisitiveness is promoted, and they learn the value of perseverance.

As they move from kindergarten through the early grades, students develop skills of observation, and they learn to examine the objects and events of their lives. At the same time, they grow in their ability to describe, interpret, evaluate, and respond to work in the visual arts. Through examination of their own work and that of other people, times, and places, students learn to unravel the essence of artwork and to appraise its purpose and value. Through these efforts, students begin to understand the meaning and impact of the visual world in which they live.

1. Content Standard: Understanding and applying media, techniques, and processes

Achievement Standard:
Students
 a. know the differences between materials, techniques, and processes
 b. describe how different materials, techniques, and processes cause different responses

 c. use different media, techniques, and processes to communicate ideas, experiences, and stories

 d. use art materials and tools in a safe and responsible manner

2. Content Standard: Using knowledge of *structures and functions

Achievement Standard:

Students

 a. know the differences among visual characteristics and purposes of art in order to convey ideas

 b. describe how different *expressive features and *organizational principles cause different responses

 c. use visual structures and functions of art to communicate ideas

3. Content Standard: Choosing and evaluating a range of subject matter, symbols, and ideas

Achievement Standard:

Students

 a. explore and understand prospective content for works of art

 b. select and use subject matter, symbols, and ideas to communicate meaning

4. Content Standard: Understanding the visual arts in relation to history and cultures

Achievement Standard:

Students

 a. know that the visual arts have both a history and specific relationships to various cultures

 b. identify specific works of art as belonging to particular cultures, times, and places

 c. demonstrate how history, culture, and the visual arts can influence each other in making and studying works of art

5. Content Standard: Reflecting upon and *assessing the characteristics and merits of their work and the work of others

Achievement Standard:

Students

 a. understand there are various purposes for creating works of visual art

 b. describe how people's experiences influence the development of specific artworks

 c. understand there are different responses to specific artworks

Achievement Standard:

Students

 a. understand and use similarities and differences between characteristics of the visual arts and other arts disciplines

 b. identify connections between the visual arts and other disciplines in the curriculum

STANDARDS IN THE ARTS

GRADES 5–8

Except as noted, the standards in this section describe the cumulative skills and knowledge expected of all students upon exiting grade 8. Students in grades 5–7 should engage in developmentally appropriate learning experiences to prepare them to achieve these standards at grade 8. These standards presume that the students have achieved the standards specified for grades K–4; they assume that the students will demonstrate higher levels of the expected skills and knowledge, will deal with increasingly complex art works, and will provide more sophisticated responses to works of art. Determining the curriculum and the specific instructional activities necessary to achieve the standards is the responsibility of states, local school districts, and individual teachers.

Terms identified by an asterisk (*) are explained in the glossary.

Dance

Through creating, performing, and responding to dance, middle school students can continue to develop skills and knowledge that enhance the important development of self-image and social relationships. Cooperation and collaboration are emphasized at this age, fostering positive interactions.

Dance education can offer a positive, healthy alternative to the many destructive choices available to adolescents. Students are encouraged to take more responsibility for the care, conditioning, and health of their bodies (both within and outside the dance class), thus learning that self-discipline is a prerequisite for achievement in dance.

Students in grades 5–8 develop a sense of themselves in relation to others and in relation to the world. As a result, they are ready to respond more thoughtfully to dance, to perceive details of *style and *choreographic structure, and to reflect upon what is communicated. The study of dance provides a unique and valuable insight into the culture or period from which it has come. Informed by social and cultural experiences, movement concepts, and dance-making processes, students integrate dance with other art forms.

1. Content Standard:	Identifying and demonstrating movement *elements and skills in performing dance

Achievement Standard:

Students

 a. demonstrate the following movement skills and explain the underlying principles: *alignment, balance, *initiation of movement, articulation of isolated body parts, weight shift, *elevation and landing, fall and recovery

 b. accurately identify and demonstrate basic dance steps, positions, and patterns for dance from two different styles or traditions[1]

 c. accurately transfer a spatial pattern from the visual to the *kinesthetic

 d. accurately transfer a rhythmic pattern from the aural to the kinesthetic

 e. identify and clearly demonstrate a range of *dynamics/*movement qualities

 f. demonstrate increasing kinesthetic awareness, concentration, and focus in performing movement skills

 g. demonstrate accurate memorization and reproduction of movement sequences

 h. describe the action and movement elements observed in a dance, using appropriate movement/dance vocabulary

1. E.g., ballet, square, Ghanaian, Middle Eastern, modern

2. Content Standard: Understanding *choreographic principles, processes, and structures

Achievement Standard:

Students

 a. clearly demonstrate the principles of contrast and transition

 b. effectively demonstrate the processes of *reordering and *chance

 c. successfully demonstrate the structures or forms of *AB, *ABA, *canon, *call and response, and *narrative

 d. demonstrate the ability to work cooperatively in a small group during the choreographic process

 e. demonstrate the following partner skills in a visually interesting way: creating contrasting and complementary shapes, taking and supporting weight

3. Content Standard: Understanding dance as a way to create and communicate meaning

Achievement Standard:

Students

 a. effectively demonstrate the difference between pantomiming and abstracting a gesture

 b. observe and explain how different accompaniment (such as sound, music, spoken text) can affect the meaning of a dance

 c. demonstrate and/or explain how lighting and costuming can contribute to the meaning of a dance

 d. create a dance that successfully communicates a topic of personal significance

4. Content Standard: Applying and demonstrating critical and creative thinking skills in dance

Achievement Standard:

Students

 a. create a movement problem and demonstrate multiple solutions; choose the most interesting solutions and *discuss the reasons for their choice

 b. demonstrate appropriate audience behavior in watching dance performances; discuss their opinions about the dances with their peers in a supportive and constructive way

 c. compare and contrast two dance compositions in terms of space (such as shape and pathways), time (such as rhythm and tempo), and force/energy (movement qualities)

 d. identify possible *aesthetic criteria for evaluating dance (such as skill of performers, originality, visual and/or emotional impact, variety and contrast)

5. Content Standard: Demonstrating and understanding dance in various cultures and historical periods

Achievement Standard:

Students

a. competently perform *folk and/or *classical dances from various cultures; describe similarities and differences in steps and movement styles

b. competently perform folk, social, and/or *theatrical dances from a broad spectrum of twentieth-century America

c. learn from resources in their own community (such as, people, books, videos) a folk dance of a different culture or a social dance of a different time period and the cultural/historical context of that dance, effectively sharing the dance and its context with their peers

d. accurately describe the role of dance in at least two different cultures or time periods

6. Content Standard: Making connections between dance and healthful living

Achievement Standard:

Students

a. identify at least three personal goals to improve themselves as dancers and steps they are taking to reach those goals

b. explain strategies to prevent dance injuries

c. create their own *warmup and discuss how that warmup prepares the body and mind for expressive purposes

7. Content Standard: Making connections between dance and other disciplines

Achievement Standard:

Students

a. create a project that reveals similarities and differences between the arts

b. cite examples of concepts used in dance and another discipline outside the arts (such as balance, shape, pattern)

c. observe the same dance both live and recorded on video; compare and contrast the aesthetic impact of the two observations

Music

The period represented by grades 5–8 is especially critical in students' musical development. The music they perform or study often becomes an integral part of their personal musical repertoire. Composing and improvising provide students with unique insight into the form and structure of music and at the same time help them to develop their creativity. Broad experience with a variety of music is necessary if students are to make informed musical judgments. Similarly, this breadth of background enables them to begin to understand the connections and relationships between music and other disciplines. By understanding the cultural and historical forces that shape social attitudes and behaviors, students are better prepared to live and work in communities that are increasingly multicultural. The role that music will play in students' lives depends in large measure on the level of skills they achieve in creating, performing, and listening to music.

Every course in music, including performance courses, should provide instruction in creating, performing, listening to, and analyzing music, in addition to focusing on its specific subject matter.

1. **Content Standard:** Singing, alone and with others, a varied repertoire of music

Achievement Standard:

Students

a. sing accurately and with good breath control throughout their singing ranges, alone and in small and large ensembles

b. sing with *expression and *technical accuracy a repertoire of vocal literature with a *level of difficulty of 2, on a scale of 1 to 6, including some songs performed from memory

c. sing music representing diverse *genres and cultures, with expression appropriate for the work being performed

d. sing music written in two and three parts

Students who participate in a choral ensemble

e. sing with expression and technical accuracy a varied repertoire of vocal literature with a level of difficulty of 3, on a scale of 1 to 6, including some songs performed from memory

2. **Content Standard:** Performing on instruments, alone and with others, a varied repertoire of music

Achievement Standard:

Students

a. perform on at least one instrument[2] accurately and independently, alone and in small and large ensembles, with good posture, good playing position, and good breath, bow, or stick control

2. E.g., band or orchestra instrument, keyboard instrument, *fretted instrument, electronic instrument

b. perform with expression and technical accuracy on at least one string, wind, percussion, or *classroom instrument a repertoire of instrumental literature with a level of difficulty of 2, on a scale of 1 to 6

c. perform music representing diverse genres and cultures, with expression appropriate for the work being performed

d. play by ear simple melodies on a melodic instrument and simple accompaniments on a harmonic instrument

Students who participate in an instrumental ensemble or class

e. perform with expression and technical accuracy a varied repertoire of instrumental literature with a level of difficulty of 3, on a scale of 1 to 6, including some solos performed from memory

3. Content Standard: Improvising melodies, variations, and accompaniments

Achievement Standard:

Students

a. improvise simple harmonic accompaniments

b. improvise melodic embellishments and simple rhythmic and melodic variations on given pentatonic melodies and melodies in major keys

c. improvise short melodies, unaccompanied and over given rhythmic accompaniments, each in a consistent *style, *meter, and *tonality

4. Content Standard: Composing and arranging music within specified guidelines

Achievement Standard:

Students

a. compose short pieces within specified guidelines,[3] demonstrating how the elements of music are used to achieve unity and variety, tension and release, and balance

b. arrange simple pieces for voices or instruments other than those for which the pieces were written

c. use a variety of traditional and nontraditional sound sources and electronic media when composing and arranging

3. E.g., a particular style, form, instrumentation, compositional technique

5. Content Standard: Reading and notating music

Achievement Standard:

Students

- **a.** read whole, half, quarter, eighth, sixteenth, and dotted notes and rests in $\frac{2}{4}$, $\frac{3}{4}$, $\frac{4}{4}$, $\frac{6}{8}$, $\frac{3}{8}$, and *alla breve meter signatures
- **b.** read at sight simple melodies in both the treble and bass clefs
- **c.** identify and define standard notation symbols for pitch, rhythm, *dynamics, tempo, *articulation, and expression
- **d.** use standard notation to record their musical ideas and the musical ideas of others

Students who participate in a choral or instrumental ensemble or class

- **e.** sightread, accurately and expressively, music with a level of difficulty of 2, on a scale of 1 to 6

6. Content Standard: Listening to, analyzing, and describing music

Achievement Standard:

Students

- **a.** describe specific music events[4] in a given aural example, using appropriate terminology
- **b.** analyze the uses of *elements of music in aural examples representing diverse genres and cultures
- **c.** demonstrate knowledge of the basic principles of meter, rhythm, tonality, intervals, chords, and harmonic progressions in their analyses of music

7. Content Standard: Evaluating music and music performances

Achievement Standard:

Students

- **a.** develop criteria for evaluating the quality and effectiveness of music performances and compositions and apply the criteria in their personal listening and performing
- **b.** evaluate the quality and effectiveness of their own and others' performances, compositions, arrangements, and improvisations by applying specific criteria appropriate for the style of the music and offer constructive suggestions for improvement

4. E.g., entry of oboe, change of meter, return of refrain

8. Content Standard: Understanding relationships between music, the other arts, and disciplines outside the arts

Achievement Standard:

Students

 a. compare in two or more arts how the characteristic materials of each art (that is, sound in music, visual stimuli in visual arts, movement in dance, human interrelationships in theatre) can be used to transform similar events, scenes, emotions, or ideas into works of art

 b. describe ways in which the principles and subject matter of other disciplines taught in the school are interrelated with those of music[5]

9. Content Standard: Understanding music in relation to history and culture

Achievement Standard:

Students

 a. describe distinguishing characteristics of representative music genres and styles from a variety of cultures

 b. classify by genre and style (and, if applicable, by historical period, composer, and title) a varied body of exemplary (that is, high-quality and characteristic) musical works and explain the characteristics that cause each work to be considered exemplary

 c. compare, in several cultures of the world, functions music serves, roles of musicians,[6] and conditions under which music is typically performed

45

5. E.g., language arts: issues to be considered in setting texts to music; mathematics: frequency ratios of intervals; sciences: the human hearing process and hazards to hearing; social studies: historical and social events and movements chronicled in or influenced by musical works

6. E.g., lead guitarist in a rock band, composer of jingles for commercials, singer in Peking opera

Theatre

In theatre, the artists create an imagined world about human beings; it is the role of the actor to lead the audience into this visual, aural, and oral world. To help students in grades 5–8 develop theatre literacy, it is important that they learn to see the created world of theatre through the eyes of the playwright, actor, designer, and director. Through active creation of theatre, students learn to understand artistic choices and to critique dramatic works. Students should, at this point, play a larger role in the planning and evaluation of their work. They should continue to use drama as a means of confidently expressing their world view, thus developing their "personal voice." The drama should also introduce students to plays that reach beyond their communities to national, international, and historically representative themes.

1. Content Standard: Script writing by the creation of *improvisations and scripted scenes based on personal experience and heritage, imagination, literature, and history

Achievement Standard:

Students

 a. individually and in groups, create characters, *environments, and *actions that create *tension and suspense

 b. refine and record dialogue and action

2. Content Standard: Acting by developing basic acting skills to portray characters who interact in improvised and scripted scenes

Achievement Standard:

Students

 a. analyze descriptions, dialogue, and actions to discover, articulate, and justify character motivation and invent character behaviors based on the observation of interactions, ethical choices, and emotional responses of people

 b. demonstrate acting skills (such as sensory recall, concentration, breath control, diction, body alignment, control of isolated body parts) to develop characterizations that suggest artistic choices

 c. in an ensemble, interact as the invented characters

3. Content Standard: Designing by developing environments for improvised and scripted scenes

Achievement Standard:

Students

 a. explain the functions and interrelated nature of scenery, properties, lighting, sound, costumes, and makeup in creating an environment appropriate for the drama

 b. analyze improvised and scripted scenes for technical requirements

 c. develop focused ideas for the environment using visual elements (line, texture, color, space), visual principles (repetition, balance, emphasis, contrast, unity), and aural qualities (pitch, rhythm, dynamics, tempo, expression) from traditional and nontraditional sources

 d. work collaboratively and safely to select and create elements of scenery, properties, lighting, and sound to signify environments, and costumes and makeup to suggest character

4. Content Standard: Directing by organizing rehearsals for improvised and scripted scenes

Achievement Standard:

Students

 a. lead small groups in planning visual and aural elements and in rehearsing improvised and scripted scenes, demonstrating social, group, and consensus skills

5. Content Standard: Researching by using cultural and historical information to support improvised and scripted scenes

Achievement Standard:

Students

 a. apply research from print and nonprint sources to script writing, acting, design, and directing choices

6. Content Standard: Comparing and incorporating art forms by analyzing methods of presentation and audience response for theatre, dramatic media (such as film, television, and *electronic media), and other art forms

Achievement Standard:

Students

 a. describe characteristics and compare the presentation of characters, environments, and actions in theatre, musical theatre, dramatic media, dance, and visual arts

 b. incorporate elements of dance, music, and visual arts to express ideas and emotions in improvised and scripted scenes

 c. express and compare personal reactions to several art forms

 d. describe and compare the functions and interaction of performing and visual artists and audience members in theatre, dramatic media, musical theatre, dance, music, and visual arts

7. Content Standard:	Analyzing, evaluating, and *constructing meanings from improvised and scripted scenes and from theatre, film, television, and electronic media productions

Achievement Standard:

Students

 a. describe and analyze the effect of publicity, study guides, programs, and physical environments on audience response and appreciation of dramatic performances

 b. articulate and support the meanings constructed from their and others' dramatic performances

 c. use articulated criteria to describe, analyze, and constructively evaluate the perceived effectiveness of artistic choices found in dramatic performances

 d. describe and evaluate the perceived effectiveness of students' contributions (as playwrights, actors, designers, and directors) to the collaborative process of developing improvised and scripted scenes

8. Content Standard:	Understanding context by analyzing the role of theatre, film, television, and electronic media in the community and in other cultures

Achievement Standard:

Students

 a. describe and compare universal characters and situations in dramas from and about various cultures and historical periods, illustrate in improvised and scripted scenes, and discuss how theatre reflects a culture

 b. explain the knowledge, skills, and discipline needed to pursue careers and avocational opportunities in theatre, film, television, and electronic media

 c. analyze the emotional and social impact of dramatic events in their lives, in the community, and in other cultures

 d. explain how culture affects the content and production values of dramatic performances

 e. explain how social concepts such as cooperation, communication, collaboration, consensus, self-esteem, risk taking, sympathy, and empathy apply in theatre and daily life

Visual Arts

Students in grades 5–8 continue to need a framework that aids them in learning the characteristics of the visual arts by using a wide range of subject matter, symbols, meaningful images, and visual expressions. They grow ever more sophisticated in their need to use the visual arts to reflect their feelings and emotions and in their abilities to evaluate the merits of their efforts. These standards provide that framework in a way that promotes the students' thinking, working, communicating, reasoning, and investigating skills and provides for their growing familiarity with the *ideas, concepts, issues, dilemmas, and knowledge important in the visual arts. As students gain this knowledge and these skills, they gain in their ability to apply the knowledge and skills in the visual arts to their widening personal worlds.

These standards present educational goals. It is the responsibility of practitioners to choose among the array of possibilities offered by the visual arts to accomplish specific educational objectives in specific circumstances. The visual arts offer the richness of drawing and painting, sculpture, and design; architecture, film, and video; and folk arts—all of these can be used to help students achieve the standards. For example, students could *create works in the *medium of videotape, engage in historical and cultural investigations of the medium, and take part in *analyzing works of art produced on videotape. The visual arts also involve varied *tools, *techniques, and *processes—all of which can play a role in students' achieving the standards, as well.

To meet the standards, students must learn vocabularies and concepts associated with various types of work in the visual arts. As they develop increasing fluency in visual, oral, and written communication, they must exhibit their greater artistic competence through all of these avenues.

In grades 5–8, students' visual expressions become more individualistic and imaginative. The problem-solving activities inherent in art making help them develop cognitive, affective, and psychomotor skills. They select and transform ideas, discriminate, synthesize and appraise, and they apply these skills to their expanding knowledge of the visual arts and to their own *creative work. Students understand that making and responding to works of visual art are inextricably interwoven and that *perception, *analysis, and critical judgment are inherent to both.

Their own art making becomes infused with a variety of images and approaches. They learn that preferences of others may differ from their own. Students refine the questions that they ask in response to artworks. This leads them to an appreciation of multiple artistic solutions and interpretations. Study of historical and cultural *contexts gives students insights into the role played by the visual arts in human achievement. As they consider examples of visual art works within historical contexts, students gain a deeper appreciation of their own values, of the values of other people, and the connection of the visual arts to universal human needs, values, and beliefs. They understand that the art of a culture is influenced by *aesthetic ideas as well as by social, political, economic, and other factors. Through these efforts, students develop an understanding of the meaning and import of the visual world in which they live.

1. Content Standard: Understanding and applying media, techniques, and processes

Achievement Standard:

Students

 a. select media, techniques, and processes; analyze what makes them effective or not effective in communicating ideas; and reflect upon the effectiveness of their choices

 b. intentionally take advantage of the qualities and characteristics of *art media, techniques, and processes to enhance communication of their experiences and ideas

2. Content Standard: Using knowledge of *structures and functions

Achievement Standard:

Students

 a. generalize about the effects of visual structures and functions and reflect upon these effects in their own work

 b. employ organizational structures and analyze what makes them effective or not effective in the communication of ideas

 c. select and use the qualities of structures and functions of art to improve communication of their ideas

3. Content Standard: Choosing and evaluating a range of subject matter, symbols, and ideas

Achievement Standard:

Students

 a. integrate visual, spatial, and temporal concepts with content to communicate intended meaning in their artworks

 b. use subjects, themes, and symbols that demonstrate knowledge of contexts, values, and aesthetics that communicate intended meaning in artworks

4. Content Standard: Understanding the visual arts in relation to history and cultures

Achievement Standard:

Students

 a. know and compare the characteristics of artworks in various eras and cultures

 b. describe and place a variety of art objects in historical and cultural contexts

 c. analyze, describe, and demonstrate how factors of time and place (such as climate, resources, ideas, and technology) influence visual characteristics that give meaning and value to a work of art

5. Content Standard: Reflecting upon and *assessing the characteristics and merits of their work and the work of others

Achievement Standard:

Students

 a. compare multiple purposes for creating works of art

 b. analyze contemporary and historic meanings in specific artworks through cultural and aesthetic inquiry

 c. describe and compare a variety of individual responses to their own artworks and to artworks from various eras and cultures

6. Content Standard: Making connections between visual arts and other disciplines

Achievement Standard:

Students

 a. compare the characteristics of works in two or more art forms that share similar subject matter, historical periods, or cultural context

 b. describe ways in which the principles and subject matter of other disciplines taught in the school are interrelated with the visual arts

51

STANDARDS IN THE ARTS

GRADES 9–12

The standards in this section describe the cumulative skills and knowledge expected of students upon graduating from high school. They presume that the students have achieved the standards specified for grades 5–8; they assume that the students will demonstrate higher levels of the expected skills and knowledge, will deal with increasingly complex art works, and will provide more sophisticated responses to works of art in at least one of the arts disciplines. Determining the curriculum and the specific instructional activities necessary to achieve the standards is the responsibility of states, local school districts, and individual teachers.

The standards establish "proficient" and "advanced" achievement levels for grades 9–12 in each discipline. The proficient level is intended for students who have completed courses of study involving relevant skills and knowledge in that discipline for one to two years beyond grade 8. The advanced level is intended for students who have completed courses of study involving relevant skills and knowledge in that discipline for three to four years beyond grade 8. Students at the advanced level are expected to achieve the standards established for the proficient as well as the advanced levels. Every student is expected to achieve the proficient level in at least one arts discipline by the time he or she graduates from high school.

Terms identified by an asterisk (*) are explained in the glossary.

Dance

High school students need to continue to dance and create dances in order to develop more highly their ability to communicate in a way that is different from the written or spoken word, or even from other visual or auditory symbol systems. They also need to respect their bodies and to understand that dance is the product of intentional and intelligent physical actions. Continued development of movement skills and creative and critical thinking skills in dance is important regardless of whether students intend a dance career.

Technical expertise and artistic expression are enhanced through reflective practice, study, and evaluation of their own work and that of others. Because dance involves *abstract images, students can develop higher order thinking skills through perceiving, analyzing, and making discriminating judgments about dance. Education in dance, which has been an integral part of human history, is also important if students are to gain a broad cultural and historical perspective. Students examine the role and meaning of dance in diverse social, cultural, and historical contexts through a variety of dance forms. Experience with dance of many cultures helps students to understand the cultural lives of others.

1. Content Standard:	Identifying and demonstrating movement *elements and skills in performing dance

Achievement Standard, Proficient:
Students

 a. demonstrate appropriate skeletal *alignment, body-part articulation, strength, flexibility, agility, and coordination in locomotor and nonlocomotor/*axial movements

 b. identify and demonstrate longer and more complex steps and patterns from two different dance *styles/traditions

 c. demonstrate *rhythmic acuity

 d. create and perform combinations and variations in a broad dynamic range

 e. demonstrate *projection while performing dance skills

 f. demonstrate the ability to remember extended movement sequences

Achievement Standard, Advanced:
Students

 g. demonstrate a high level of consistency and reliability in performing technical skills

 h. perform technical skills with artistic expression, demonstrating clarity, *musicality, and stylistic nuance

 i. refine technique through self-evaluation and correction

2. Content Standard: Understanding *choreographic principles, processes, and structures

Achievement Standard, Proficient:

Students

 a. use *improvisation to generate movement for choreography
 b. demonstrate understanding of structures or forms (such as *palindrome, theme and variation, rondo, round, contemporary forms selected by the student) through brief dance studies
 c. choreograph a duet demonstrating an understanding of choreographic principles, processes, and structures

Achievement Standard, Advanced:

Students

 d. demonstrate further development and refinement of the proficient skills to create a small group dance with coherence and aesthetic unity
 e. accurately describe how a choreographer manipulated and developed the basic movement content in a dance

3. Content Standard: Understanding dance as a way to create and communicate meaning

Achievement Standard, Proficient:

Students

 a. formulate and answer questions about how movement choices communicate abstract ideas in dance
 b. demonstrate understanding of how personal experience influences the interpretation of a dance
 c. create a dance that effectively communicates a contemporary social theme

Achievement Standard, Advanced:

Students

 d. examine ways that a dance creates and conveys meaning by considering the dance from a variety of perspectives
 e. compare and contrast how meaning is communicated in two of their own choreographic works

4. Content Standard: Applying and demonstrating critical and creative thinking skills in dance

Achievement Standard, Proficient:

Students

 a. create a dance and revise it over time, articulating the reasons for their artistic decisions and what was lost and gained by those decisions

 b. establish a set of *aesthetic criteria and apply it in evaluating their own work and that of others

 c. formulate and answer their own aesthetic questions (such as, What is it that makes a particular dance that dance? How much can one change that dance before it becomes a different dance?)

Achievement Standard, Advanced:

Students:

 d. *discuss how skills developed in dance are applicable to a variety of careers

 e. analyze the *style of a choreographer or cultural form; then create a dance in that style[1]

 f. analyze issues of ethnicity, gender, social/economic class, age and/or physical condition in relation to dance

5. Content Standard: Demonstrating and understanding dance in various cultures and historical periods

Achievement Standard, Proficient:

Students

 a. perform and describe similarities and differences between two contemporary *theatrical forms of dance

 b. perform or discuss the traditions and technique of a *classical dance form[2]

 c. create and answer twenty-five questions about dance and dancers prior to the twentieth century

 d. analyze how dance and dancers are portrayed in contemporary media

Achievement Standard, Advanced:

Students

 e. create a time line illustrating important dance events in the twentieth century, placing them in their social/historical/cultural/political contexts

 f. compare and contrast the role and significance of dance in two different social/historical/cultural/political contexts

1. Choreographers that could be analyzed include George Balanchine, Alvin Ailey, Laura Dean; cultural forms include bharata natyam, classical ballet.

2. E.g., Balinese, ballet

6. Content Standard: Making connections between dance and healthful living

Achievement Standard, Proficient:

Students

 a. reflect upon their own progress and personal growth during their study of dance

 b. effectively communicate how lifestyle choices affect the dancer

 c. analyze historical and cultural images of the body in dance and compare these to images of the body in contemporary media

Achievement Standard, Advanced:

Students:

 d. discuss challenges facing professional performers in maintaining healthy lifestyles

7. Content Standard: Making connections between dance and other disciplines

Achievement Standard, Proficient:

Students

 a. create an interdisciplinary project based on a theme identified by the student, including dance and two other disciplines

 b. clearly identify commonalities and differences between dance and other disciplines with regard to fundamental concepts such as materials, elements, and ways of communicating meaning

 c. demonstrate/discuss how *technology can be used to reinforce, enhance, or alter the dance idea in an interdisciplinary project

Achievement Standard, Advanced:

Students:

 d. compare one choreographic work to one other artwork from the same culture and time period in terms of how those works reflect the artistic/cultural/historical context

 e. create an interdisciplinary project using media technologies (such as video, computer) that presents dance in a new or enhanced form (such as video dance, video/computer–aided live performance, or animation)

58

Music

The study of music contributes in important ways to the quality of every student's life. Every musical work is a product of its time and place, although some works transcend their original settings and continue to appeal to humans through their timeless and universal attraction. Through singing, playing instruments, and composing, students can express themselves creatively, while a knowledge of notation and performance traditions enables them to learn new music independently throughout their lives. Skills in analysis, evaluation, and synthesis are important because they enable students to recognize and pursue excellence in their musical experiences and to understand and enrich their environment. Because music is an integral part of human history, the ability to listen with understanding is essential if students are to gain a broad cultural and historical perspective. The adult life of every student is enriched by the skills, knowledge, and habits acquired in the study of music.

Every course in music, including performance courses, should provide instruction in creating, performing, listening to, and analyzing music, in addition to focusing on its specific subject matter.

1. Content Standard: Singing, alone and with others, a varied repertoire of music

Achievement Standard, Proficient:
Students

a. sing with *expression and *technical accuracy a large and varied repertoire of vocal literature with a *level of difficulty of 4, on a scale of 1 to 6, including some songs performed from memory

b. sing music written in four parts, with and without accompaniment

c. demonstrate well-developed ensemble skills

Achievement Standard, Advanced:
Students

d. sing with expression and technical accuracy a large and varied repertoire of vocal literature with a level of difficulty of 5, on a scale of 1 to 6

e. sing music written in more than four parts

f. sing in small ensembles with one student on a part

2. Content Standard: Performing on instruments, alone and with others, a varied repertoire of music

Achievement Standard, Proficient:
Students

a. perform with expression and technical accuracy a large and varied repertoire of instrumental literature with a level of difficulty of 4, on a scale of 1 to 6

b. perform an appropriate part in an ensemble, demonstrating well-developed ensemble skills

c. perform in small ensembles with one student on a part

Achievement Standard, Advanced:

Students

d. perform with expression and technical accuracy a large and varied repertoire of instrumental literature with a level of difficulty of 5, on a scale of 1 to 6

3. Content Standard: Improvising melodies, variations, and accompaniments

Achievement Standard, Proficient:

Students

a. improvise stylistically appropriate harmonizing parts

b. improvise rhythmic and melodic variations on given pentatonic melodies and melodies in major and minor keys

c. improvise original melodies over given chord progressions, each in a consistent *style, *meter, and *tonality

Achievement Standard, Advanced:

Students

d. improvise stylistically appropriate harmonizing parts in a variety of styles

e. improvise original melodies in a variety of styles, over given chord progressions, each in a consistent style, meter, and tonality

4. Content Standard: Composing and arranging music within specified guidelines

Achievement Standard, Proficient:

Students

a. compose music in several distinct styles, demonstrating creativity in using the *elements of music for expressive effect

b. arrange pieces for voices or instruments other than those for which the pieces were written in ways that preserve or enhance the expressive effect of the music

c. compose and arrange music for voices and various acoustic and electronic instruments, demonstrating knowledge of the ranges and traditional usages of the sound sources

Achievement Standard, Advanced:

Students

d. compose music, demonstrating imagination and technical skill in applying the principles of composition

5. Content Standard: Reading and notating music

Achievement Standard, Proficient:

Students

a. demonstrate the ability to read an instrumental or vocal score of up to four *staves by describing how the elements of music are used

Students who participate in a choral or instrumental ensemble or class

b. sightread, accurately and expressively, music with a level of difficulty of 3, on a scale of 1 to 6

Achievement Standard, Advanced:

Students

c. demonstrate the ability to read a full instrumental or vocal score by describing how the elements of music are used and explaining all transpositions and clefs

d. interpret nonstandard notation symbols used by some 20th-century composers

Students who participate in a choral or instrumental ensemble or class

e. sightread, accurately and expressively, music with a level of difficulty of 4, on a scale of 1 to 6

6. Content Standard: Listening to, analyzing, and describing music

Achievement Standard, Proficient:

Students

a. analyze aural examples of a varied repertoire of music, representing diverse *genres and cultures, by describing the uses of elements of music and expressive devices

b. demonstrate extensive knowledge of the technical vocabulary of music

c. identify and explain compositional devices and techniques used to provide unity and variety and tension and release in a musical work and give examples of other works that make similar uses of these devices and techniques

Achievement Standard, Advanced:

Students

d. demonstrate the ability to perceive and remember music events by describing in detail significant events[3] occurring in a given aural example

e. compare ways in which musical materials are used in a given example relative to ways in which they are used in other works of the same genre or style

f. analyze and describe uses of the elements of music in a given work that make it unique, interesting, and expressive

3. E.g., fugal entrances, chromatic modulations, developmental devices

7. Content Standard: Evaluating music and music performances

Achievement Standard, Proficient:

Students

- a. evolve specific criteria for making informed, critical evaluations of the quality and effectiveness of performances, compositions, arrangements, and improvisations and apply the criteria in their personal participation in music
- b. evaluate a performance, composition, arrangement, or improvisation by comparing it to similar or exemplary models

Achievement Standard, Advanced:

Students

- c. evaluate a given musical work in terms of its aesthetic qualities and explain the musical means it uses to evoke feelings and emotions

8. Content Standard: Understanding relationships between music, the other arts, and disciplines outside the arts

Achievement Standard, Proficient:

Students

- a. explain how elements, artistic processes (such as imagination or craftsmanship), and organizational principles (such as unity and variety or repetition and contrast) are used in similar and distinctive ways in the various arts and cite examples
- b. compare characteristics of two or more arts within a particular historical period or style and cite examples from various cultures
- c. explain ways in which the principles and subject matter of various disciplines outside the arts are interrelated with those of music[4]

Achievement Standard, Advanced:

Students

- d. compare the uses of characteristic elements, artistic processes, and organizational principles among the arts in different historical periods and different cultures
- e. explain how the roles of creators, performers, and others involved in the production and presentation of the arts are similar to and different from one another in the various arts[5]

4. E.g., language arts: compare the ability of music and literature to convey images, feelings, and meanings; physics: describe the physical basis of tone production in string, wind, percussion, and electronic instruments and the human voice and of the transmission and perception of sound

5. E.g., creators: painters, composers, choreographers, playwrights; performers: instrumentalists, singers, dancers, actors; others: conductors, costumers, directors, lighting designers

Achievement Standard, Proficient:

Students

a. classify by genre or style and by historical period or culture unfamiliar but representative aural examples of music and explain the reasoning behind their classifications

b. identify sources of American music genres,[6] trace the evolution of those genres, and cite well-known musicians associated with them

c. identify various roles[7] that musicians perform, cite representative individuals who have functioned in each role, and describe their activities and achievements

Achievement Standard, Advanced:

Students

d. identify and explain the stylistic features of a given musical work that serve to define its aesthetic tradition and its historical or cultural context

e. identify and describe music genres or styles that show the influence of two or more cultural traditions, identify the cultural source of each influence, and trace the historical conditions that produced the synthesis of influences

6. E.g., swing, Broadway musical, blues

7. E.g., entertainer, teacher, transmitter of cultural tradition

Theatre

In grades 9–12, students view and construct dramatic works as metaphorical visions of life that embrace connotative meanings, juxtaposition, ambiguity, and varied interpretations. By creating, performing, analyzing, and critiquing dramatic performances, they develop a deeper understanding of personal issues and a broader worldview that includes global issues. Since *theatre in all its forms reflects and affects life, students should learn about representative dramatic *texts and performances and the place of that work and those events in history. Classroom work becomes more formalized with the advanced students participating in theatre, film, television, and *electronic media productions.

1. Content Standard:	Script writing through *improvising, writing, and refining *scripts based on personal experience and heritage, imagination, literature, and history

Achievement Standard, Proficient:

Students

 a. construct imaginative scripts and collaborate with actors to refine scripts so that story and meaning are conveyed to an audience

Achievement Standard, Advanced:

Students

 b. write theatre, film, television, or electronic media scripts in a variety of *traditional and new forms that include original characters with unique dialogue that motivates *action

2. Content Standard:	Acting by developing, communicating, and sustaining characters in *improvisations and *informal or *formal productions

Achievement Standard, Proficient:

Students

 a. analyze the physical, emotional, and social dimensions of characters found in dramatic texts from various genres and media

 b. compare and demonstrate various *classical and contemporary acting *techniques and methods

 c. in an *ensemble, create and sustain characters that communicate with audiences

Achievement Standard, Advanced:

Students

 d. demonstrate artistic discipline to achieve an ensemble in rehearsal and performance

 e. create consistent characters from classical, contemporary, realistic, and nonrealistic dramatic texts in informal and formal theatre, film, television, or electronic media productions

3. Content Standard: Designing and producing by conceptualizing and realizing artistic interpretations for informal or formal productions

Achievement Standard, Proficient:

Students

- a. explain the basic physical and chemical properties of the technical aspects of theatre (such as light, color, electricity, paint, and makeup)
- b. analyze a variety of dramatic texts from cultural and historical perspectives to determine production requirements
- c. develop designs that use visual and aural elements to convey *environments that clearly support the text
- d. apply technical knowledge and skills to collaboratively and safely create functional scenery, properties, lighting, sound, costumes, and makeup
- e. design coherent stage management, promotional, and business plans

Achievement Standard, Advanced:

Students

- f. explain how scientific and technological advances have impacted set, light, sound, and costume design and implementation for theatre, film, television, and electronic media productions
- g. collaborate with directors to develop *unified production concepts that convey the metaphorical nature of the *drama for informal and formal theatre, film, television, or electronic media productions
- h. safely construct and efficiently operate technical aspects of theatre, film, television, or electronic media productions
- i. create and reliably implement production schedules, stage management plans, promotional ideas, and business and *front of house procedures for informal and formal theatre, film, television, or electronic media productions

65

4. Content Standard: Directing by interpreting dramatic texts and organizing and conducting rehearsals for informal or formal productions

Achievement Standard, Proficient:

Students

- a. develop multiple interpretations and visual and aural production choices for scripts and production ideas and choose those that are most interesting
- b. justify selections of text, interpretation, and visual and aural *artistic choices
- c. effectively communicate directorial choices to a small ensemble for improvised or scripted scenes

Achievement Standard, Advanced:

Students

- d. explain and compare the roles and interrelated responsibilities of the various personnel involved in theatre, film, television, and electronic media productions

e. collaborate with designers and actors to develop aesthetically unified production concepts for informal and formal theatre, film, television, or electronic media productions

f. conduct auditions, cast actors, direct scenes, and conduct production meetings to achieve production goals

5. Content Standard: Researching by evaluating and synthesizing cultural and historical information to support artistic choices

Achievement Standard, Proficient:

Students

a. identify and research cultural, historical, and symbolic clues in dramatic texts, and evaluate the validity and practicality of the information to assist in making artistic choices for informal and formal productions

Achievement Standard, Advanced:

Students

b. research and describe appropriate historical production designs, techniques, and performances from various cultures to assist in making artistic choices for informal and formal theatre, film, television, or electronic media productions

6. Content Standard: Comparing and integrating art forms by analyzing traditional theatre, dance, music, visual arts, and *new art forms

Achievement Standard, Proficient:

Students

a. describe and compare the basic nature, materials, elements, and means of communicating in theatre, *dramatic media, musical theatre, dance, music, and the visual arts

b. determine how the nondramatic art forms are modified to enhance the expression of ideas and emotions in theatre

c. illustrate the integration of several arts media in informal presentations

Achievement Standard, Advanced:

Students

d. compare the interpretive and expressive natures of several art forms in a specific culture or historical period

e. compare the unique interpretive and expressive natures and *aesthetic qualities of traditional arts from various cultures and historical periods with contemporary new art forms (such as performance art)

f. integrate several arts and/or media in theatre, film, television, or electronic media productions

7. Content Standard: Analyzing, critiquing, and *constructing meanings from informal and formal theatre, film, television, and electronic media productions

Achievement Standard, Proficient:

Students

a. construct social meanings from informal and formal productions and from dramatic performances from a variety of cultures and historical periods, and relate these to current personal, national, and international issues

b. articulate and justify personal *aesthetic criteria for critiquing dramatic texts and events that compare perceived artistic intent with the final aesthetic achievement

c. analyze and critique the whole and the parts of dramatic performances, taking into account the context, and constructively suggest alternative artistic choices

d. constructively evaluate their own and others' collaborative efforts and artistic choices in informal and formal productions

Achievement Standard, Advanced:

Students

e. construct personal meanings from nontraditional dramatic performances

f. analyze, compare, and evaluate differing critiques of the same dramatic texts and performances

g. critique several dramatic works in terms of other aesthetic philosophies (such as the underlying ethos of Greek drama, French classicism with its unities of time and place, Shakespeare and romantic forms, India classical drama, Japanese kabuki, and others)

h. analyze and evaluate critical comments about personal dramatic work explaining which points are most appropriate to inform further development of the work

8. Content Standard: Understanding context by analyzing the role of theatre, film, television, and electronic media in the past and the present

Achievement Standard, Proficient:

Students

a. compare how similar themes are treated in drama from various cultures and historical periods, illustrate with informal performances, and discuss how theatre can reveal universal concepts

b. identify and compare the lives, works, and influence of representative theatre artists in various cultures and historical periods

c. identify cultural and historical sources of American theatre and musical theatre

d. analyze the effect of their own cultural experiences on their dramatic work

Achievement Standard, Advanced:

Students

e. analyze the social and aesthetic impact of underrepresented theatre and film artists

f. analyze the relationships among cultural values, freedom of artistic expression, ethics, and artistic choices in various cultures and historical periods

g. analyze the development of dramatic forms, production practices, and theatrical traditions across cultures and historical periods and explain influences on contemporary theatre, film, television, and electronic media productions

Visual Arts

In grades 9–12, students extend their study of the visual arts. They continue to use a wide range of subject matter, symbols, meaningful images, and visual expressions. They grow more sophisticated in their employment of the visual arts to reflect their feelings and emotions and continue to expand their abilities to evaluate the merits of their efforts. These standards provide a framework for that study in a way that promotes the maturing students' thinking, working, communicating, reasoning, and investigating skills. The standards also provide for their growing familiarity with the ideas, concepts, issues, dilemmas, and knowledge important in the visual arts. As students gain this knowledge and these skills, they gain in their ability to apply knowledge and skills in the visual arts to their widening personal worlds.

The visual arts range from the folk arts, drawing, and painting, to sculpture and design, from architecture to film and video—and any of these can be used to help students meet the educational goals embodied in these standards. For example, graphic design (or any other field within the visual arts) can be used as the basis for creative activity, historical and cultural investigations, or *analysis throughout the standards. The visual arts involve varied *tools, *techniques, and *processes—all of which also provide opportunities for working toward the standards. It is the responsibility of practitioners to choose from among the array of possibilities offered by the visual arts to accomplish specific educational objectives in specific circumstances.

To meet the standards, students must learn vocabularies and concepts associated with various types of work in the visual arts. As they develop greater fluency in communicating in visual, oral, and written form, they must exhibit greater artistic competence through all of these avenues.

In grades 9–12, students develop deeper and more profound works of visual art that reflect the maturation of their creative and problem-solving skills. Students understand the multifaceted interplay of different *media, styles, forms, techniques, and processes in the creation of their work.

Students develop increasing abilities to pose insightful questions about *contexts, processes, and criteria for evaluation. They use these questions to examine works in light of various analytical methods and to express sophisticated ideas about visual relationships using precise terminology. They can evaluate artistic character and *aesthetic qualities in works of art, nature, and human-made environments. They can reflect on the nature of human involvement in art as a viewer, creator, and participant.

Students understand the relationships among art forms and between their own work and that of others. They are able to relate understandings about the historical and cultural contexts of art to situations in contemporary life. They have a broad and in-depth understanding of the meaning and import of the visual world in which they live.

1. Content Standard: Understanding and applying media, techniques, and processes

Achievement Standard, Proficient:

Students

 a. apply media, techniques, and processes with sufficient skill, confidence, and sensitivity that their intentions are carried out in their artworks

b. conceive and *create works of visual art that demonstrate an understanding of how the communication of their ideas relates to the media, techniques, and processes they use

Achievement Standard, Advanced:

Students

c. communicate ideas regularly at a high level of effectiveness in at least one visual arts medium

d. initiate, define, and solve challenging *visual arts problems.independently using intellectual skills such as analysis, synthesis, and evaluation

2. Content Standard: Using knowledge of *structures and functions

Achievement Standard, Proficient:

Students

a. demonstrate the ability to form and defend judgments about the characteristics and structures to accomplish commercial, personal, communal, or other purposes of art

b. evaluate the effectiveness of artworks in terms of organizational structures and functions

c. create artworks that use *organizational principles and functions to solve specific visual arts problems

Achievement Standard, Advanced:

Students

d. demonstrate the ability to compare two or more perspectives about the use of organizational principles and functions in artwork and to defend personal evaluations of these perspectives

e. create multiple solutions to specific visual arts problems that demonstrate competence in producing effective relationships between structural choices and artistic functions

3. Content Standard: Choosing and evaluating a range of subject matter, symbols, and ideas

Achievement Standard, Proficient:

Students

a. reflect on how artworks differ visually, spatially, temporally, and functionally, and describe how these are related to history and culture

b. apply subjects, symbols, and ideas in their artworks and use the skills gained to solve problems in daily life

Achievement Standard, Advanced:

Students

c. describe the origins of specific images and ideas and explain why they are of value in their artwork and in the work of others

d. evaluate and defend the validity of sources for content and the manner in which subject matter, symbols, and images are used in the students' works and in significant works by others

4. Content Standard: Understanding the visual arts in relation to history and cultures

Achievement Standard, Proficient:

Students

 a. differentiate among a variety of historical and cultural contexts in terms of characteristics and purposes of works of art

 b. describe the function and explore the meaning of specific art objects within varied cultures, times, and places

 c. analyze relationships of works of art to one another in terms of history, aesthetics, and culture, justifying conclusions made in the analysis and using such conclusions to inform their own art making

Achievement Standard, Advanced:

Students

 d. analyze and interpret artworks for relationships among form, context, purposes, and critical models, showing understanding of the work of critics, historians, aestheticians, and artists

 e. analyze common characteristics of visual arts evident across time and among cultural/ethnic groups to formulate analyses, evaluations, and interpretations of meaning

71

5. Content Standard: Reflecting upon and assessing the characteristics and merits of their work and the work of others

Achievement Standard, Proficient:

Students

 a. identify intentions of those creating artworks, explore the implications of various purposes, and justify their analyses of purposes in particular works

 b. describe meanings of artworks by analyzing how specific works are created and how they relate to historical and cultural contexts

 c. reflect analytically on various interpretations as a means for understanding and evaluating works of visual art

Achievement Standard, Advanced:

Students

 d. correlate responses to works of visual art with various techniques for communicating meanings, ideas, attitudes, views, and intentions

6. Content Standard: Making connections between visual arts and other disciplines

Achievement Standard, Proficient:

Students

- **a.** compare the materials, *technologies, media, and processes of the visual arts with those of other arts disciplines as they are used in creation and types of analysis
- **b.** compare characteristics of visual arts within a particular historical period or style with ideas, issues, or themes in the humanities or sciences

Achievement Standard, Advanced:

Students

- **c.** synthesize the creative and analytical principles and techniques of the visual arts and selected other arts disciplines, the humanities, or the sciences

APPENDIX 1

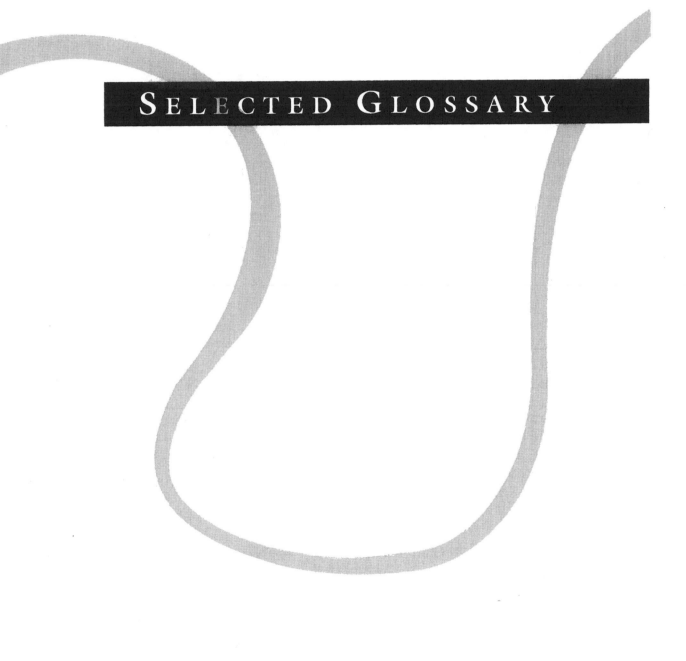

SELECTED GLOSSARY

Terms identified by an asterisk (*) are explained further in the glossary.

Dance

AB. A two-part compositional form with an A theme and a B theme; the binary form consists of two distinct, self-contained sections that share either a character or quality (such as the same tempo, movement quality, or style).

ABA. A three-part compositional form in which the second section contrasts with the first section. The third section is a restatement of the first section in a condensed, abbreviated, or extended form.

Abstract. To remove movement from a particular or representative context and (by manipulating it with elements of space, time, and force) create a new sequence or dance that retains the essence of the original.

Action. A movement event.

Aesthetic criteria. Standards on which to make judgments about the artistic merit of a work of art.

Alignment. The relationship of the skeleton to the line of gravity and the base of support.

Axial movement. Any movement that is anchored to one spot by a body part using only the available space in any direction without losing the initial body contact. Movement is organized around the axis of the body rather than designed for travel from one location to another; also known as nonlocomotor movement.

Call and response. A structure that is most often associated with African music and dance forms, although it is also used elsewhere. One soloist/group performs with the second soloist/group entering "in response" to the first.

Canon. *Choreographic form that reflects the musical form of the same name, in which individuals and groups perform the same movement/phrase beginning at different times.

Chance. A choreographic process in which *elements are specifically chosen and defined but randomly structured to create a dance or movement phrase. This process demands high levels of concentration in performance to deal effectively with free-association and surprise structures that appear spontaneously.

Choreographic. Describes a dance sequence that has been created with specific intent.

Choreographic Structure. The specific compositional forms in which movement is structured to create a dance.

Classical. Dance that has been developed into highly stylized structures within a culture. Generally developed within the court or circle of power in a society.

Discuss. To engage in oral, written, or any other appropriate form of presentation.

Dynamics. The expressive content of human movement, sometimes called qualities or efforts. Dynamics manifest the interrelationships among the elements of space, time, and force/energy. See also *movement quality.

Elements. The use of the body moving in space and time with force/energy.

Elevation. The body's propulsion into the air away from the floor, such as in a leap, hop, or jump.

Folk. Dances that are usually created and performed by a specific group within a culture. Generally these dances originated outside the courts or circle of power within a society.

Improvisation. Movement that is created spontaneously, ranging from free-form to highly structured environments, but always with an element of chance. Provides the dancer with the opportunity to bring together elements quickly, and requires focus and concentration. Improvisation is instant and simultaneous choreography and performance.

Initiation. Point at which a movement is said to originate. This particularly refers to specific body parts and is generally said to be either distal (from the limbs or head) or central (from the torso).

Kinesphere. The movement space, or the space surrounding the body in stillness and in motion, which includes all directions and levels both close to the body and as far as the person can reach with limbs or torso. See *personal space.

Kinesthetic. Refers to the ability of the body's sensory organs in the muscles, tendons, and joints to respond to stimuli while dancing or viewing a dance.

Levels. The height of the dancer in relation to the floor.

Locomotor movement. Movement that travels from place to place, usually identified by weight transference on the feet. Basic locomotor steps are the walk, run, leap, hop, and jump and the irregular rhythmic combinations of the skip (walk and hop), slide (walk and leap) and gallop (walk and leap).

Movement quality. The identifying attributes created by the release, follow-through, and termination of energy, which are key to making movement become dance. Typical terms denoting qualities include sustained, swing, percussive, collapse, and vibratory and effort combinations such as float, dab, punch, and glide.

Movement theme. A complete idea in movement that is manipulated and developed within a dance.

Musicality. The attention and sensitivity to the musical elements of dance while creating or performing.

Narrative. Choreographic structure that follows a specific story line and intends to convey specific information through that story.

Nonlocomotor movement. See *axial movement

Palindrome. A choreographic structure used with a phrase or longer sequence of movement in which the phrase, for example, is first performed proceeding from movement 1 to movement 2, etc.; when the last movement of the phrase is completed, the phrase is retrograded from the penultimate movement to the first movement. (A commonly used example in prose is "Able was I ere I saw Elba." In this example, the letters are the same forward to the "r" in "ere" as they are backward to the "r.")

Personal space. The "space bubble" or the kinesphere that one occupies; it includes all levels, planes, and directions both near and far from the body's center.

Phrase. A brief sequence of related movements that has a sense of rhythmic completion.

Projection. A confident presentation of one's body and energy to vividly communicate movement and meaning to an audience; performance quality.

Reordering. A choreographic process in which known and defined elements (specific movements, movement phrases, etc.) are separated from their original relationship and restructured in a different pattern.

Rhythmic acuity. The physical, auditory recognition of various complex time elements.

Style. A distinctive manner of moving; the characteristic way dance is done, created, or performed that identifies the dance of a particular performer, choreographer, or period.

Technology. Electronic media (such as video, computers, or lasers) used as tools to create, learn, explain, document, analyze, or present dance.

Theatrical. Dance genres primarily developed for the stage (such as jazz and tap).

Traditional dance. The term "traditional" is used to denote those dances and dance forms that have arisen out of the tradition of a people, such as the dances of bharata natyam, noh, or the folk dances of indigenous peoples of Europe or other areas.

Warmup. Movements and/or movement phrases designed to raise the core body temperature and bring the mind into focus for the dance activities to follow.

Music

Alla breve. The *meter signature ₵ indicating the equivalent of $\frac{2}{2}$ time.

Articulation. In performance, the characteristics of attack and decay of tones and the manner and extent to which tones in sequence are connected or disconnected.

Classroom instruments. Instruments typically used in the general music classroom, including, for example, recorder-type instruments, chorded zithers, mallet instruments, simple percussion instruments, *fretted instruments, keyboard instruments, and electronic instruments.

Dynamic levels, dynamics. Degrees of loudness.

Elements of music. Pitch, rhythm, harmony, *dynamics, *timbre, texture, *form.

Expression, expressive, expressively. With appropriate *dynamics, phrasing, *style, and interpretation and appropriate variations in dynamics and tempo.

Form. The overall structural organization of a music composition (e.g., AB, ABA, call and response, rondo, theme and variations, sonata-allegro) and the interrelationships of music events within the overall structure.

Fretted instruments. Instruments with frets (strips of material across the fingerboard allowing the strings to be stopped at predetermined locations), such as guitar, ukulele, and sitar.

Genre. A type or category of music (e.g., sonata, opera, oratorio, art song, gospel, suite, jazz, madrigal, march, work song, lullaby, barbershop, Dixieland).

Intonation. The degree to which pitch is accurately produced in performance, particularly among the players in an ensemble.

Level of difficulty. For purposes of these standards, music is classified into six levels of difficulty:

Level 1—Very easy. Easy keys, *meters, and rhythms; limited ranges.

Level 2—Easy. May include changes of tempo, key, and meter; modest ranges.

Level 3—Moderately easy. Contains moderate technical demands, expanded ranges, and varied interpretive requirements.

Level 4—Moderately difficult. Requires well-developed *technical skills, attention to phrasing and interpretation, and ability to perform various meters and rhythms in a variety of keys.

Level 5—Difficult. Requires advanced technical and interpretive skills; contains key signatures with numerous sharps or flats, unusual meters, complex rhythms, subtle *dynamic requirements.

Level 6—Very difficult. Suitable for musically mature students of exceptional competence.

(Adapted with permission from *NYSSMA Manual,* Edition XXIII, published by the New York State School Music Association, 1991.)

Meter. The grouping in which a succession of rhythmic pulses or beats is organized; indicated by a *meter signature at the beginning of a work.

Meter signature. An indicator of the *meter of a musical work, usually presented in the form of a fraction, the denominator of which indicates the unit of measurement and the numerator of which indicates the number of units that make up a measure.

MIDI (Musical Instrument Digital Interface). Standard specifications that enable electronic instruments such as the synthesizer, sampler, sequencer, and drum machine from any manufacturer to communicate with one another and with computers.

Ostinato. A short musical pattern that is repeated persistently throughout a composition.

Staves. Plural of staff (the five parallel lines on which music is written).

Style. The distinctive or characteristic manner in which the *elements of music are treated. In practice, the term may be applied to, for example, composers (the style of Copland), periods (Baroque style), media (keyboard style), nations (French style), *form or type of composition (fugal style, contrapuntal style), or *genre (operatic style, bluegrass style).

Technical accuracy, technical skills. The ability to perform with appropriate *timbre, *intonation, and diction and to play or sing the correct pitches and rhythms.

Timbre. The character or quality of a sound that distinguishes one instrument, voice, or other sound source from another.

Tonality. The harmonic relationship of tones with respect to a definite center or point of rest; fundamental to much of Western music from *ca.* 1600.

Theatre

Action. The core of a theatre piece; the sense of forward movement created by the sense of time and/or the physical and psychological motivations of characters.

Aesthetic criteria. Criteria developed about the visual, aural, and oral aspects of the witnessed event, derived from cultural and emotional values and cognitive meaning.

Aesthetic qualities. The emotional values and cognitive meanings derived from interpreting a work of art; the symbolic nature of art.

Artistic choices. Selections made by theatre artists about situation, action, direction, and design in order to convey meaning.

Classical. A dramatic form and production techniques considered of significance in earlier times, in any culture or historical period.

Classroom dramatizations. The act of creating character, dialogue, action, and environment for the purpose of exploration, experimentation, and study in a setting where there is no formal audience observation except for that of fellow students and teachers.

Constructed meaning. The personal understanding of dramatic/artistic intentions and *actions and their social and personal significance, selected and organized from the aural, oral, and visual symbols of a dramatic production.

Drama. The art of composing, writing, acting, or producing plays; a literary composition intended to portray life or character or to tell a story usually involving conflicts and emotions exhibited through action and dialogue, designed for theatrical performance.

Dramatic media. Means of telling of stories by way of stage, film, television, radio, or computer discs.

Electronic media. Means of communication characterized by the use of technology, e.g., radio, computers, e.g., virtual reality.

Ensemble. The dynamic interaction and harmonious blending of the efforts of the many artists involved in the dramatic activity of theatrical production.

Environment. Physical surroundings that establish place, time, and atmosphere/mood; the physical conditions that reflect and affect the emotions, thoughts, and actions of characters.

Formal production. The staging of a dramatic work for presentation for an audience.

Front of house. Box office and lobby.

Improvisation. The spontaneous use of movement and speech to create a character or object in a particular situation.

Informal production. The exploration of all aspects of a dramatic work (such as visual, oral, aural) in a setting where experimentation is emphasized. Similar to classroom dramatizations with classmates and teachers as the usual audience.

New art forms. The novel combination of traditional arts and materials with emerging technology (such as performance art, videodiscs, virtual reality).

Role. The characteristic and expected social behavior of an individual in a given position (e.g., mother, employer). Role portrayal is likely to be more predictable and one-dimensional than character portrayal.

Script. The written dialogue, description, and directions provided by the playwright.

Social pretend play. When two or more children engage in unsupervised enactments; participants use the play to explore social knowledge and skills.

Tension. The atmosphere created by unresolved, disquieting, or inharmonious situations that human beings feel compelled to address.

Text. The basis of dramatic activity and performance; a written script or an agreed-upon structure and content for an improvisation.

81

Theatre. The imitation/representation of life, performed for other people; the performance of dramatic literature; *drama; the milieu of actors and playwrights, the place that is the setting for dramatic performances.

Theatre literacy. The ability to create, perform, perceive, analyze, critique, and understand dramatic performances.

Traditional forms. Forms that use time-honored theatrical practices.

Unified production concept. A brief statement, metaphor, or expression of the essential meaning of a play that orders and patterns all the play's parts; a perceptual device used to evoke associated visual and aural presuppositions serving to physicalize and unify the production values of a play.

Visual Arts

Visual Arts. A broad category that includes the traditional fine arts such as drawing, painting, printmaking, sculpture; communication and design arts such as film, television, graphics, product design; architecture and environmental arts such as urban, interior, and landscape design; folk arts; and works of art such as ceramics, fibers, jewelry, works in wood, paper, and other materials.

Aesthetics. A branch of philosophy that focuses on the nature of beauty, the nature and value of art, and the inquiry processes and human responses associated with those topics.

Analysis. Identifying and examining separate parts as they function independently and together in creative works and studies of the visual arts.

Art criticism. Describing and evaluating the media, processes, and meanings of works of visual art, and making comparative judgments.

Art elements. Visual arts components, such as line, texture, color, form, value, and space.

Art history. A record of the visual arts, incorporating information, interpretations, and judgments about art objects, artists, and conceptual influences on developments in the visual arts.

Art materials. Resources used in the creation and study of visual art, such as paint, clay, cardboard, canvas, film, videotape, models, watercolors, wood, and plastic.

Art media. Broad categories for grouping works of visual art according to the *art materials used.

Assess. To analyze and determine the nature and quality of achievement through means appropriate to the subject.

Context. A set of interrelated conditions (such as social, economic, political) in the visual arts that influence and give meaning to the development and reception of thoughts, ideas, or concepts and that define specific cultures and eras.

Create. To produce works of visual art using materials, techniques, processes, elements, and analysis; the flexible and fluent generation of unique, complex, or elaborate ideas.

Expressive features. Elements evoking affects such as joy, sadness, or anger.

Expression. A process of conveying ideas, feelings, and meanings through selective use of the communicative possibilities of the visual arts.

Ideas. A formulated thought, opinion, or concept that can be represented in visual or verbal form.

Organizational principles. Underlying characteristics in the visual arts, such as repetition, balance, emphasis, contrast, and unity.

Perception. Visual and sensory awareness, discrimination, and integration of impressions, conditions, and relationships with regard to objects, images, and feelings.

Process. A complex operation involving a number of methods or techniques, such as the addition and subtraction processes in sculpture, the etching and intaglio processes in printmaking, or the casting or constructing processes in making jewelry.

Structures. Means of organizing the components of a work into a cohesive and meaningful whole, such as sensory qualities, organizational principles, expressive features, and functions of art.

Techniques. Specific methods or approaches used in a larger process; for example, graduation of value or hue in painting or conveying linear perspective through overlapping, shading, or varying size or color.

Technologies. Complex machines used in the study and creation of art, such as lathes, presses, computers, lasers, and video equipment.

Tools. Instruments and equipment used by students to create and learn about art, such as brushes, scissors, brayers, easels, knives, kilns, and cameras.

83

Visual arts problems. Specific challenges based in thinking about and using visual arts components.

APPENDIX 2

OUTLINES OF SEQUENTIAL LEARNING

The content and achievement standards for dance, music, theatre, and the visual arts are presented in the following pages in outline form.

Insofar as possible, the achievement standards are arranged so that similar skills and knowledge are aligned horizontally, left to right, representing sequential learning from level to level: K–4, 5–8, 9–12 proficient, 9–12 advanced. The sequential nature of the learning called for in the standards is evident in reading the standards this way.

A bracket indicates that an achievement standard at one level is related to more than one achievement standard at another level. An arrow indicates that, although the standard appearing at a lower level is not repeated verbatim, the students at higher grade levels are expected to demonstrate higher levels of those skills, to deal with more complex examples, and to respond to works of art in increasingly more sophisticated ways. A line indicates that a standard appearing at a higher level may not be developmentally appropriate at the lower level, although learning experiences leading toward the skills associated with the standard are assumed to be taking place.

Dance

= The achievement standard at one level is related to more than one achievement standard at another level.

= The Standard appearing at a lower grade level is not repeated, but students at this grade level are expected to achieve that standard, demonstrating higher levels of skill, dealing with more complex examples, and responding to works of art in increasingly sophisticated ways.

= The standard appearing at a higher level may not be developmentally appropriate at this level, although learning experiences leading toward the skills associated with the standard are assumed to be taking place.

1. Content Standard: Identifying and demonstrating movement elements and skills in performing dance

GRADES K–4	GRADES 5–8	GRADES 9–12, PROFICIENT	GRADES 9–12, ADVANCED
Achievement Standard: Students	**Achievement Standard:** Students	**Achievement Standard, Proficient:** Students	**Achievement Standard:** Students:
accurately demonstrate nonlocomotor/axial movements (such as bend, twist, stretch, swing) (a)	demonstrate the following movement skills and explain the underlying principles: alignment, balance, initiation of movement, articulation of isolated body parts, weight shift, elevation and landing, fall and recovery (a)	demonstrate appropriate skeletal alignment, body-part articulation, strength, flexibility, agility, and coordination in locomotor and nonlocomotor/axial movements (a)	demonstrate a high level of consistency and reliability in performing technical skills (g)
accurately demonstrate eight basic locomotor movements (such as walk, run, hop, jump, leap, gallop, slide, and skip), traveling forward, backward, sideward, diagonally, and turning (b)	accurately identify and demonstrate basic dance steps, positions and patterns for dance from two different styles or traditions (b)	identify and demonstrate longer and more complex steps and patterns from two different dance styles/traditions (b)	perform technical skills with artistic expression, demonstrating clarity, musicality, and stylistic nuance (h)
demonstrate accuracy in moving to a musical beat and responding to changes in tempo (f)	accurately transfer a rhythmic pattern from the aural to the kinesthetic (d)	demonstrate rhythmic acuity (c)	
demonstrate kinesthetic awareness, concentration, and focus in performing movement skills (g)	demonstrate increasing kinesthetic awareness, concentration, and focus in performing movement skills (f)	demonstrate projection while performing dance skills (e)	
create shapes at low, middle, and high levels (c)			
demonstrate the ability to define and maintain personal space (d)	accurately transfer a spatial pattern from the visual to the kinesthetic (c)		
demonstrate movements in straight and curved pathways (e)			
	identify and clearly demonstrate a range of dynamics/movement qualities (e)	create and perform combinations and variations in a broad dynamic range (d)	
attentively observe and accurately describe the action (such as skip, gallop) and movement elements (such as levels, directions) in a brief movement study (h)	describe the action and movement elements observed in a dance, using appropriate movement/dance vocabulary (h)		

GRADES K-4 GRADES 5-8 GRADES 9-12, PROFICIENT GRADES 9-12, ADVANCED

demonstrate accurate memorization and reproduction of movement sequences (g)

demonstrate the ability to remember extended movement sequences (f)

refine technique through self-evaluation and correction (i)

GRADES K–4	GRADES 5–8	GRADES 9–12, PROFICIENT	GRADES 9–12, ADVANCED

2. Content Standard: Understanding choreographic principles, processes, and structures

GRADES K–4	GRADES 5–8	GRADES 9–12, PROFICIENT	GRADES 9–12, ADVANCED
Achievement Standard: Students	**Achievement Standard:** Students	**Achievement Standard:** Students	**Achievement Standard:** Students
create a sequence with a beginning, middle and end both with and without a rhythmic accompaniment. Identify each of these parts of the sequence (a)	clearly demonstrate the principles of contrast and transition (a)		
improvise, create and perform dances based on their own ideas and concepts from other sources (b)	effectively demonstrate the processes of reordering and chance (b)	use improvisation to generate movement for choreography (a)	
use improvisation to discover and invent movement and to solve movement problems (c)			
create a dance phrase, accurately repeat it, and then vary it (making changes in the time, space and/or force/energy) (d)	successfully demonstrate the structures or forms of AB, ABA, canon, call and response, and narrative (c)	demonstrate understanding of structures or forms (such as palindrome, theme and variation, rondo, round, contemporary forms selected by the student) through brief dance studies (b)	demonstrate further development and refinement of the proficient skills to create a small group dance with coherence and aesthetic unity (d)
demonstrate the ability to work effectively alone and with a partner (e)	demonstrate the ability to work cooperatively in a small group during the choreographic process (d)	choreograph a duet demonstrating an understanding of choreographic principles, processes, and structures (c)	
demonstrate the following partner skills: copying, leading and following, mirroring (f)	demonstrate the following partner skills in a visually interesting way: creating contrasting and complementary shapes, taking and supporting weight (e)		accurately describe how a choreographer manipulated and developed the basic movement content in a dance (e)

GRADES K–4	GRADES 5–8	GRADES 9–12, PROFICIENT	GRADES 9–12, ADVANCED

3. Content Standard: Understanding dance as a way to create and communicate meaning

GRADES K–4	GRADES 5–8	GRADES 9–12, PROFICIENT	GRADES 9–12, ADVANCED
Achievement Standard: Students	**Achievement Standard:** Students:	**Achievement Standard:** Students	**Achievement Standard:** Students:
observe and discuss how dance is different from other forms of human movement (such as sports, everyday gestures) (a)	effectively demonstrate the difference between pantomiming and abstracting a gesture (a)	formulate and answer questions about how movement choices communicate abstract ideas in dance (a)	examine ways that a dance creates and conveys meaning by considering the dance from a variety of perspectives (d)
take an active role in a class discussion about interpretations of and reactions to a dance (b)	observe and explain how different accompaniment (such as sound, music, spoken text) can affect the meaning of a dance (b)	demonstrate understanding of how personal experience influences the interpretation of a dance (b)	compare and contrast how meaning is communicated in two of their own choreographic works (e)
present their own dances to peers and discuss their meanings with competence and confidence (c)	demonstrate and/or explain how lighting and costuming can contribute to the meaning of a dance (c)	create a dance that effectively communicates a contemporary social theme (c)	
	create a dance that successfully communicates a topic of personal significance (d)		

4. Content Standard: Applying and demonstrating critical and creative thinking skills in dance

GRADES K–4	GRADES 5–8	GRADES 9–12, PROFICIENT	GRADES 9–12, ADVANCED
Achievement Standard: Students	**Achievement Standard:** Students:	**Achievement Standard:** Students	**Achievement Standard:** Students:
explore, discover, and realize multiple solutions to a given movement problem; choose their favorite solution and discuss the reasons for that choice (a)	create a movement problem and demonstrate multiple solutions; choose the most interesting solutions and discuss the reasons for their choice (a)	create a dance and revise it over time, articulating the reasons for their artistic decisions and what was lost and gained by those decisions (a)	
observe two dances and discuss how they are similar and different in terms of one of the elements of dance (such as space, through body shapes, levels, pathways) (b)	demonstrate appropriate audience behavior in watching dance performances; discuss their opinions about the dances with their peers in a supportive and constructive way (b)	establish a set of aesthetic criteria and apply it in evaluating their own work and that of others (b)	discuss how skills developed in dance are applicable to a variety of careers (d)
	compare and contrast two dance compositions in terms of space (such as shape and pathways), time (such as rhythm and tempo), and force/energy (such as movement qualities) (c)	formulate and answer their own aesthetic questions (such as, What is it that makes a particular dance that dance? How much can one change that dance before it becomes a different dance? (c)	analyze the style of a choreographer or cultural form; then create a dance in that style (e)
	identify possible aesthetic criteria for evaluating dance (such as skill of performers, originality, visual and/or emotional impact, variety and contrast) (d)		analyze issues of ethnicity, gender, social/economic class, age and/or physical condition in relation to dance (f)

The *TATE*
Cookbook

Paul King and
Michael Driver

with Jenny Linford

TATE GALLERY PUBLISHING

Cover and frontispiece: WILLIAM STRANG *Bank Holiday* 1912
Back cover: SIR WILLIAM NICHOLSON *Mushrooms* 1940
Below: SALVADOR DALÍ *Lobster Telephone* 1936

© Tate Gallery 1996 All rights reserved
Published by Tate Gallery Publishing Limited
Millbank, London SW1P 4RG

Paul King and Michael Driver have asserted their right to be identified as the
authors of this work

ISBN 1 85437 191 6

A catalogue record for this book is available from the British Library

Designed by Behram Kapadia
Printed in Italy by Amilcare Pizzi

Contents

Introduction

The Tate Gallery Restaurant was set up in 1972 in the Gallery's original refreshment room which had been decorated in 1926–7 by the young English artist, Rex Whistler, with his now famous murals *The Expedition in Pursuit of Rare Meats*. For over twenty years visitors to the Gallery have enjoyed the best of English and international cooking in these unique surroundings. Although some visitors came specifically for their favourite British dishes, such as Roast Beef with Yorkshire Pudding or Steak, Kidney and Mushroom Pie, the newer, lighter menus are equally popular. The restaurant also became widely known for its exceptional wine list, which is discussed by an expert from the restaurant on page 12.

Over the years, the restaurant has always sought to develop and refresh its repertoire. This book reproduces a selection of the most successful recipes of the last twenty years, adapted for the domestic kitchen. These dishes were served during the period from 1974 until 1996 when Michael Driver was head chef, and although some visitors came specifically for their favourite traditional British dishes many of the newer recipes became equally popular and are also included.

Part of the reputation of the restaurant was gained with its updated versions of historic British cooking. Buttered Crab, for example, is an ancient West Country recipe. Umbles Paste, which combines layers of chicken breast with layers of liver and ham 'pâté' flavoured with allspice, cloves and parsley, is another traditional recipe from the West Country – umbles is a medieval

Left: Rex Whistler *The Expedition in Pursuit of Rare Meats* 1926–7 (detail)

word for livers or offal. Veal Kidneys Florentine, which mixes kidneys, spinach, herbs and mace in a pastry case, was a favourite dish in the court of Queen Elizabeth I. A book found in the British Library, dated 1664, provided another source for recipes. This was *The Court and Kitchin of Elizabeth, commonly called Joan Cromwell, the Wife of the Late Userper*, a record of the food served in the house of Oliver Cromwell. From the ingredients listed there – raisins, blanched almonds, olives, pickled cucumber, lemon, pickled French beans, shrimps 'and possibly the minced flesh of a roast hen, and sturgeon, all in a good salad sauce' – the restaurant adapted the recipe for Joan Cromwell Salad. Also included is a recipe for Pie with Fruit Ryfshews, which dates from the eleventh century. Ryfshews is an old English word for contents, in this case a filling of English summer fruits.

Along with these traditional English foods, the recipes printed here also reflect a more international approach to cooking, for example Monkfish and Avocado Roulade with Chilli Salsa, or Feta-filled Breasts of Chicken with Tomato, Olive and Anchovy Sauce, which combines a basil purée with feta cheese, spread with a spinach leaf on a slice of chicken and rolled.

THE WHISTLER MURALS

In 1925 the Gallery received an offer from Sir Joseph Duveen to fund the decoration of what was then the Gallery refreshment room. Sir Joseph was keen to support and encourage young British artists, and in 1926 the Tate commissioned Rex Whistler (1905–45) to produce a series of murals to cover the entire upper walls of the room. He was given complete freedom to devise a design, and he worked on the murals in 1926 and 1927. They were unveiled at an opening celebration in November 1927. Whistler was at the beginning of his career, and the murals were to lead to several further commissions for him.

The subject of the murals is *The Expedition in Pursuit of Rare Meats*. A hunting party is formed, including a princess and her maid, a prince, a colonel, a captain, a pantry boy and the son of an impoverished Polish nobleman. At the start of the mural they are

seen leaving a palace and riding across the countryside, spearing sturgeon, hunting for truffles and other delicacies. The hunters encounter wild and mythical beasts on their journey through the mountains and forests including a leopard and a unicorn. On the window wall of the restaurant they travel through a strange country, where they are viewed by Chinese mandarins through telescopes and given scented tea. They are forced to cross a broken bridge and manage to resist the temptations of mermaids. On the end wall they finally recognise the palace through the park, and return home bearing flour, caviar, terrines of foie gras, lobsters, scented tea and stuffed quails.

Rex Whistler remained a successful artist, working in England until the second world war, where he died in action in 1945. The Whistler Room still provides an unusual and special setting for diners visiting the Tate Gallery.

Overleaf: REX WHISTLER *The Expedition in Pursuit of Rare Meats* 1926–7 (detail)

The Tate Gallery Restaurant Wine List

From its inception, the wine list at the Tate Gallery Restaurant has enjoyed a reputation for excellence. The emphasis was originally on French wines, but the list has now expanded to encompass other European countries, as well as the Antipodes, California and Oregon, reflecting improved wine-making techniques from around the world and offering a comprehensive choice for the most discerning palate. Innovative combinations of herbs, spices and other ingredients in the menu encourage the flouting of etiquette when selecting wines, and a exceptional range of half-bottles is now available to add to the possibilities for experiment.

Rather than recommending a specific wine for each dish in *The Tate Cookbook*, here we offer general advice for selecting a bottle to accompany your home-cooked recipe. The wines of Burgundy, for example, pair perfectly with many of the fish dishes listed in both the starter and main course sections. Their buttery richness and full-bodied maturity suit highly flavoured starters such as Prawn Mousse with Smoked Salmon, Smoked Trout Pâté or Buttered Crab. Sole, Spinach and Prawn Parcels, Fresh Lobster Salad or Salmon, Mushrooms and Rice in Puff Pastry all invite the purist to select a favourite producer. Sauzet, Latour, Leflaive and Henri Clerc are all represented in the Tate's cellar, not forgetting an excellent Rully from Drouhin in the underrated Chalonnaise. All are available in half bottles, as are a variety of Sauternes, which marry well with Poached Pears with Stilton and Walnut Quenelles. Seasoned game and offal dishes, such as Venison Pâté en Croûte with Cumberland Sauce or Umbles Paste, call for the spicy complexity of wines from the Rhône Valley, among them the collection of Perrin wines which includes the Châteauneuf-du-Pape and their Côte du Rhone Coudoulet de Beaucastel. The fourth

generation of Perrins at Domaine de Beaucastel pride themselves on being amongst the best wine-makers in France. Their wines rival the intensity and concentration of the Bordelais, and are suited to most meat dishes, especially a complex recipe such as Feta-filled Breasts of Chicken with Tomato, Olive and Anchovy Sauce.

The wines of Bordeaux, however, including those of such celebrated châteaux as Latour at Pauillac, Palmer at Margaux and Cheval Blanc in St Emilion, remain the focal point of the Tate Restaurant's list. They complement the old English dishes – Steak, Kidney and Mushroom Pie or Fillet of Beef Camargo. The list's Burgundy wines, from both Côte de Beaune and Côte de Nuits, are unrivalled for value and quality, and perfectly suit the lighter meat dishes. The additional cheese course is a must for those keen to try the Pommards and Chambertins.

The wines of Italy and Spain are ripe, concentrated and lusty. Often overshadowed by their French neighbours, they now reside deservedly in the Tate's list. Rioja, Navarra or Montepulciano would pair ideally with Parmesan Crumb Lamb Steaks with Caper Sauce.

Not for the faint hearted, the puddings in *The Tate Cookbook* provide an opportunity for delightful over-indulgence. Steamed puddings with piping sauces and roulades spilling over with lucious fruits tempt the diner to that last half-bottle or glass of Beaume de Venis. Suduiraut, Doisy Daene and La Tour Blanche, with their sumptuous sweetness, are also ideal companions.

The wine list at the Tate is continually under review to maintain a constant level of excellence. The extensive range of vintages in each section continue to delight oenologist and amateur àlike.

PENNY MUNOZ

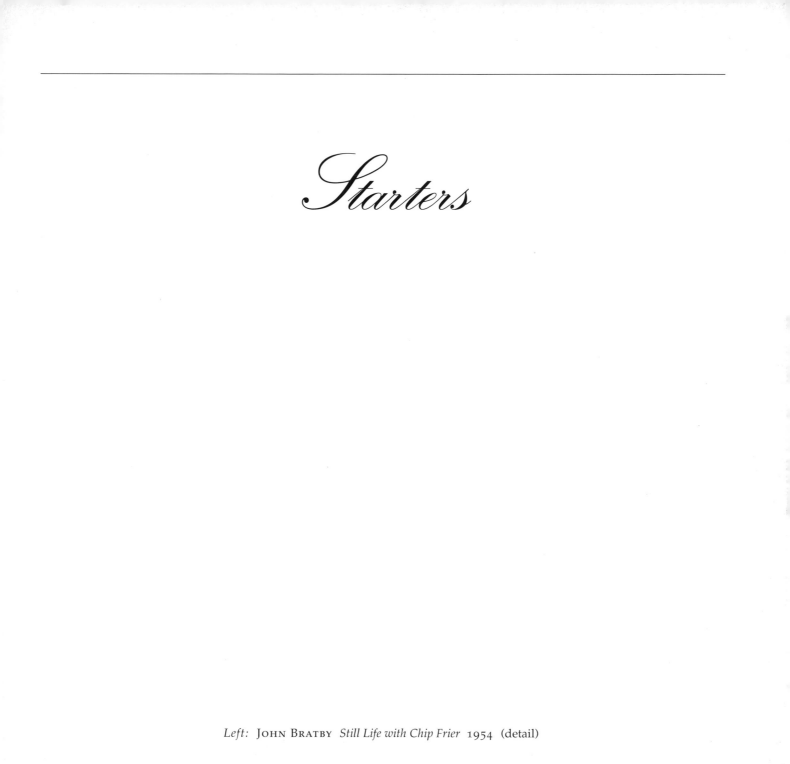

Starters

Left: JOHN BRATBY *Still Life with Chip Frier* 1954 (detail)

Gravadlax

Serves 4

*This famous Scandinavian salmon dish must be made
24 hours in advance.*

450 G / 1 LB SALMON FILLET

JUICE OF 1 LEMON

SEA SALT

2 TABLESPOONS BRANDY

2 BUNCHES OF FRESH DILL

OLIVE OIL

Mustard Mayonnaise

1 EGG YOLK

1 TEASPOON VINEGAR

SALT AND GROUND WHITE PEPPER

½ TEASPOON DRY ENGLISH MUSTARD

125 ML / 4 FL OZ / ½ CUP OLIVE OIL

Rub the salmon with the lemon juice, sea salt and brandy. Finely chop the dill and sprinkle it over the salmon. Place the salmon in a shallow dish and cover completely with the olive oil. Leave in the refrigerator for 24 hours.

To make the mustard mayonnaise: beat the egg yolk until pale and thick. Beat in the vinegar, salt, pepper and mustard. Beating constantly, add the olive oil, a ½-teaspoon at a time, until the mixture thickens into mayonnaise. Add 1 teaspoon boiling water, whisking well. Taste and correct the seasoning. Set aside to cool.

To serve, slice the salmon as finely as possible and serve with the mustard mayonnaise.

SIR STANLEY SPENCER *Dinner on the Hotel Lawn* 1956–7

Monkfish and Avocado Roulade with Chilli Salsa

Serves 8

Roulade
115 G / 4 OZ / 1 STICK UNSALTED BUTTER
6 EGGS
200 G / 7 OZ / 1¼ CUPS GROUND ALMONDS
SALT AND FRESHLY GROUND BLACK PEPPER
1 RIPE AVOCADO
JUICE OF 1 LEMON

Monkfish Filling
1 ONION
500 G / 1 LB 2 OZ MONKFISH FILLET
2 TABLESPOONS OLIVE OIL
3 TABLESPOONS DRY WHITE WINE
JUICE AND GRATED ZEST OF 1 LEMON
6 TABLESPOONS MAYONNAISE (HOME-MADE OR SHOP-BOUGHT)
3 TABLESPOONS CHOPPED DILL
SALT AND FRESHLY GROUND BLACK PEPPER

Chilli Salsa
8 RIPE TOMATOES
1 ONION
2 CLOVES GARLIC
2 FRESH RED CHILLIES
4 SPRIGS OF BASIL
JUICE OF 1 LEMON
50–125 ML / 2–4 FL OZ / ¼–½ CUP TOMATO JUICE
SALT AND FRESHLY GROUND BLACK PEPPER

To make the roulade: pre-heat the oven to Gas Mark 4/180°C/350°F. Line a 30 × 20 cm/12 × 9 inch Swiss roll tin with siliconised baking parchment. Melt the butter in a saucepan over low heat.

18

Separate the eggs. Whisk the yolks until smooth and fold in the ground almonds. Season with freshly ground pepper. Peel and chop the avocado. Blend or mash it with the lemon juice until smooth. Mix into the yolk mixture.

Whisk the egg whites with a pinch of salt until stiff. Using a metal spoon, carefully fold them into the avocado mixture. Then carefully mix in the melted butter with a metal spoon. Spread the mixture onto the lined Swiss roll tin. Bake for 15 minutes until set and spongy. Set aside to cool.

While the roulade is baking prepare the monkfish filling: Peel and finely chop the onion. Cube the monkfish. Heat the olive oil in a saucepan and gently fry the onion until softened. Add the monkfish. Fry briefly and pour white wine over the fish. Sizzle briefly then add the lemon juice and zest. Cover and simmer until the fish is cooked through. Leave to cool. Drain the monkfish and flake into the mayonnaise. Mix in the dill and season with salt and freshly ground pepper.

To make the chilli salsa: briefly scald the tomatoes in boiling water, then peel and chop them and remove their cores. Peel and finely chop the onion. Peel and crush the garlic. Cut the caps off the chillies and chop finely. Tear the basil. Mix together the chopped tomatoes, onion, garlic, chillies and basil. Mix in the lemon juice and enough tomato juice to give a chutney-like consistency.

Turn the roulade on to a sheet of baking parchment. Carefully peel off the sheet it was baked on. Spread evenly with the monkfish filling. Carefully roll up the roulade lengthwise.

Serve a slice of the roulade with a portion of chilli salsa on the side.

Prawn Mousse with Smoked Salmon

Serves 4

225 G / 8 OZ SMOKED SALMON SLICES

225 G / 8 OZ COOKED PEELED PRAWNS

6 TABLESPOONS CHOPPED DILL

JUICE OF ½ LEMON

55 G / 2 OZ / ¼ CUP CRÈME FRAÎCHE

15 G / ½ OZ LEAF GELATINE

1 EGG WHITE

SALT AND FRESHLY GROUND BLACK PEPPER

Line four small ramekins with the smoked salmon slices. The salmon must overlap the edges so that it can be folded over the prawn mousse.

Put the prawns, dill and lemon juice in a food processor and blend to a paste. Season with salt and freshly ground pepper to taste and mix in the crème fraîche.

Soften the gelatine in a little cold water. Strain the gelatine and melt it gently over a low heat, stirring constantly. Do not allow it to boil.

Gradually mix one-third of the prawn mixture into the gelatine, stirring it in well. Mix this into the remaining prawn mixture. Whisk the egg white until stiff. Carefully and thoroughly fold it into the prawn mixture with a metal spoon. Divide the prawn mousse between the salmon-lined ramekins. Fold the overlapping salmon slices over the mousse. Cover and chill for 2 hours or until set.

To serve, carefully turn the mousses out of the ramekins on to serving dishes. Accompany with salad leaves and warm toast or bread rolls.

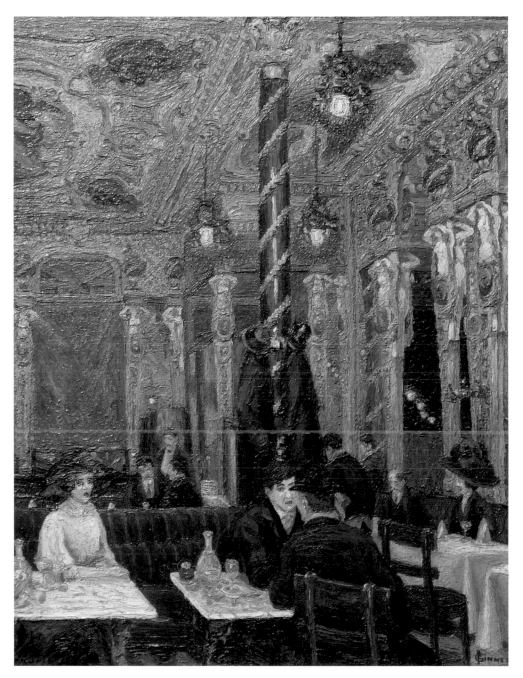

CHARLES GINNER *The Café Royal* 1911

Smoked Trout Pâté

Serves 4

½ ONION

55 G / 2 OZ / ½ STICK BUTTER

2 TABLESPOONS CHOPPED CHIVES

280 G / 10 OZ SMOKED TROUT FILLETS

2 TABLESPOONS DOUBLE CREAM

JUICE OF ½ LEMON

SALT AND FRESHLY GROUND BLACK PEPPER

J.M.W. TURNER *A Study of Fish: Two Tench, a Trout and a Perch* c.1822–4 (detail)

Peel and finely chop the onion. Melt half of the butter in a saucepan and gently cook the onion until softened. Add the chives and the remaining butter and cook over a low heat until the butter has melted.

Mash the smoked trout fillets with a fork and mix into the cooked onion. Beat in the double cream and lemon juice to make a smooth paste. Season with salt and freshly ground pepper.

Line a 15 × 7.5 × 7.5 cm/6 × 3 × 3 in terrine with greaseproof paper and turn the pâté into it, smoothing the surface with a spatula. Cover and chill for 2 hours.

Serve with slices of toasted brioche.

Buttered Crab

Serves 4

3 SLICES OF WHITE BREAD

BUNCH OF CHERVIL

55 G / 2 OZ / ½ STICK BUTTER

125 G / 4 OZ FRESH CRABMEAT

2 TABLESPOONS SHERRY

75 ML / 2½ FL OZ / ⅓ CUP DOUBLE CREAM

SALT AND FRESHLY GROUND BLACK PEPPER

GENEROUS PINCH OF GROUND MACE

4 LEMON SLICES

Grate or process the bread into crumbs. Finely chop half the chervil. Melt the butter in a saucepan over a low heat and mix in the crabmeat, breadcrumbs, chopped chervil, sherry and cream. Season with salt, freshly ground pepper and mace. Simmer gently for 15 minutes, stirring often. Set aside to cool.

To serve, divide the mixture between four ramekins and garnish with the lemon slices and remaining chervil.

Chicken, Parma Ham and Vegetable Terrine

Serves 8 as a starter

You will need a 15 × 7.5 × 7.5 cm/6 × 3 × 3 inch metal terrine for this recipe.

1 RED PEPPER

1 GREEN PEPPER

1 CLOVE GARLIC

8 SPRIGS OF BASIL

2 TABLESPOONS OLIVE OIL

450 G / 1 LB SPINACH

SALT AND FRESHLY GROUND BLACK PEPPER

FRESHLY GRATED NUTMEG

3 CHICKEN SUPREMES

25 G / 1 OZ / ¼ STICK BUTTER

4 SLICES OF PARMA HAM

Pre-heat the oven to Gas Mark 5/190°C/375°F. De-seed the red and green peppers and slice them into strips. Peel and chop the garlic. Roughly tear the basil. Place the pepper strips, garlic and basil in a roasting tin and pour 1 tablespoon of the olive oil over them. Bake for 20 minutes until softened.

Meanwhile, wash the spinach. Heat ½ tablespoon of the olive oil in a large saucepan. Add the spinach and season with salt, freshly ground pepper and the freshly grated nutmeg. Cook briefly until the spinach wilts. Drain, cool and squeeze dry.

Carefully, using a good sharp knife, slice each chicken supreme lengthwise into three slices. Season with salt and pepper. Melt the butter in a saucepan over low heat.

Brush the terrine with the remaining olive oil. Make a layer of chicken slices, brush with melted butter, then add a layer of spinach, followed by Parma ham and roasted pepper strips. Repeat the process until all the

JOHN GRIFFIER THE ELDER *A Turkey and other Fowl in a Park* 1710

ingredients are used up. Cover the terrine with siliconised baking parchment and then aluminium foil. Check that the oven temperature is still Gas Mark 5/190°C/375°F. Place the terrine in a deep roasting tin and surround it with enough hot water to reach halfway up the terrine tin. Bake for 50 minutes to 1 hour until cooked through. To check this pierce with a skewer in the middle and feel the skewer. If it is heated through the terrine is cooked. Remove from the oven and cool.

Serve slices of the terrine on a bed of salad leaves.

Venison Pâté en Croûte with Cumberland Sauce

Serves 4

½ ONION

40 G / 1½ OZ CHICKEN LIVERS

85 G / 3 OZ VENISON

85 G / 3 OZ BELLY PORK

1 CLOVE GARLIC

55 G / 2 OZ / ½ STICK BUTTER

1 BAY LEAF

SALT AND FRESHLY GROUND BLACK PEPPER

2 TABLESPOONS DOUBLE CREAM

280 G / 10 OZ PUFF PASTRY

1 EGG

Cumberland Sauce

55 G / 2 OZ REDCURRANT JELLY

JUICE AND GRATED ZEST OF ½ ORANGE

JUICE AND GRATED ZEST OF ½ LEMON

50 ML / 2 FL OZ / ¼ CUP PORT

Peel and finely chop the onion. Dice the chicken livers, venison and belly pork. Peel and crush the garlic.

Melt the butter in a saucepan. Add the chicken livers, venison, pork, onion, garlic and bay leaf and cook over a low heat for 30 minutes until the meat is cooked. Remove the bay leaf. Season with salt and freshly ground pepper. Put the meat and double cream in a food processor and mix to a smooth paste.

Pre-heat the oven to Gas Mark 4/180°C/350°F. Line four ramekins with greaseproof paper and divide the mixture between them. Bake for 30 minutes. Set aside to cool.

Meanwhile, make the Cumberland sauce: place the redcurrant jelly, orange and lemon juice and zest and the port in a saucepan. Bring to the boil, mixing well. Set aside to cool.

Pre-heat the oven to Gas Mark 4/180°C/350°F. Roll out the puff pastry and cut it into four even-sized rectangles. Beat the egg. Carefully turn out the baked pâté from the ramekins. Wrap each pâté mould in puff pastry, sealing the edges with beaten egg and brushing the puff pastry parcel with the egg. Bake for 20 minutes.

Serve each of the the venison pâté parcels with a spoonful of Cumberland sauce.

Smoked Venison and Cream Cheese Roulade

Serves 8

50 ML / 2 FL OZ / ¼ CUP DARK RUM

40 G / 1½ OZ RAISINS

40 G/ 1½ OZ SULTANAS

125 G / 4½ OZ SLICED SMOKED VENISON

140 G /5 OZ CREAM CHEESE

FRESHLY GROUND BLACK PEPPER

10 TABLESPOONS CHOPPED FRESH PARSLEY, CHIVES AND OREGANO

Heat the rum. Place the raisins and sultanas in bowl, pour the rum over them and leave to soak for 1 hour.

Take a long piece of clingfilm and cover with the venison slices, overlapping them so as to leave no gaps and leaving a long edge of clingfilm.

Mix the cream cheese, freshly ground pepper and herbs until well mixed and softened. Drain the raisins and sultanas, discarding the rum, and mix them into the cream cheese.

Gently spread the cream cheese mixture over the venison. Take hold of the long clingfilm edge and slowly pull away the clingfilm, so that the venison slices roll up to form a roulade. Check that the roulade is tightly rolled. Chill for 3 hours until hardened.

Serve each slice of roulade on a bed of salad leaves.

Umbles Paste

Serves 8 as a starter

450 G / 1 LB BONELESS CHICKEN BREASTS

½ CHICKEN STOCK CUBE

85 G / 3 OZ CHICKEN LIVERS

300 G / 10½ OZ HAM

1 SHALLOT

55 G / 2 OZ / ½ STICK BUTTER

2 TABLESPOONS CHOPPED PARSLEY

SALT AND FRESHLY GROUND BLACK PEPPER

PINCH OF ALLSPICE

PINCH OF GROUND CLOVES

Gently simmer the chicken breasts in water until cooked through. Remove with a slotted spoon and set aside to cool. Reserve 125 ml/4 fl oz/½ cup of the water the chicken was cooked in. Heat it through and stir in the stock cube until dissolved. Set aside.

Finely chop the chicken livers and ham. Peel and chop the shallot. Melt half the butter in a frying pan and fry the shallot until softened. Add the chicken livers, ham and parsley. Cook for 10 minutes and season with salt, freshly ground pepper, the allspice and the ground cloves. Put the liver mixture into a food processor and blend to form a paste.

Pre-heat the oven to Gas Mark 5/190°C/375°F. Cut the chicken breasts into thin slices. Butter a deep heatproof dish and arrange a layer of chicken in the dish, then a layer of the liver paste. Repeat the process until all the chicken is used, finishing with a layer of chicken. Pour the reserved chicken stock over the layers. Place the dish in a deep tray with enough hot water to come halfway up its side. Bake for 1 hour.

Melt the remaining butter and pour it over the baked umbles paste. Chill.

Serve slices of the umble paste with a salad garnish and warm toast or bread rolls.

Right: LESLIE HUNTER *Kitchen Utensils c.1914–18*

Spiced Lamb Rice Paper Parcels

Serves 4 as a starter

25 G / 8 OZ LAMB FILLET

½ ONION

1 CLOVE GARLIC

1 CM / ½ INCH PIECE OF ROOT GINGER

1 CARROT

½ STICK CELERY

2 SPRING ONIONS

1 TABLESPOON OLIVE OIL

1 TEASPOON TABASCO SAUCE

1 TEASPOON OYSTER SAUCE

2 TABLESPOONS CHOPPED CORIANDER

2 TABLESPOONS CHOPPED BASIL

SALT AND FRESHLY GROUND BLACK PEPPER

1 EGG

24 SHEETS OF RICE PAPER

2 TEASPOONS CORNFLOUR

OIL FOR DEEP-FRYING

Slice the lamb into short fine strips. Peel and finely chop the onion, garlic and root ginger. Peel and grate the carrot. Chop the celery and spring onions into short fine strips.

Heat the olive oil in a frying pan and fry the onion, garlic and ginger until fragrant. Add the lamb strips. When the lamb is brown, add the carrot, celery and spring onions. Mix well and add the Tabasco sauce, oyster sauce, coriander and basil. Season with salt and freshly ground pepper. Fry until the vegetables are just softened. Set aside to cool.

Beat the egg. Divide the lamb mixture into eight portions. Layer three sheets of rice paper on top of each other, brushing each layer with a little of the beaten egg. Place a portion of lamb in the centre of the layered rice paper. Fold over the edges, brush with the egg and roll over tightly into a cigar shape. Place on a tray sprinkled with the cornflour. Repeat the process to make eight parcels in all.

Heat the oil. Deep-fry the rolls in batches until golden-brown; remove them with a slotted spoon and drain on kitchen paper.

Serve at once.

Cucumber, Yoghurt and Mint Soup

Serves 4

2 CUCUMBERS

6 SPRIGS OF FRESH MINT

150 ML /5 FL OZ / ⅔ CUP NATURAL YOGHURT

DRY WHITE WINE (OPTIONAL)

SALT AND FRESHLY GROUND BLACK PEPPER

1 SLICE OF WHITE BREAD

1 TABLESPOON OLIVE OIL

Peel and roughly chop the cucumbers. Chop the mint. Blend the cucumber, mint and yoghurt together until smooth. Thin with a little dry white wine if necessary. Season with salt and freshly ground pepper to taste. Cover and chill.

Finely cube the bread. Heat the olive oil in a frying pan and fry the cubes until golden-brown.

Serve the cucumber soup garnished with the croûtons.

Fennel Soup

Serves 4

2 LARGE BULBS OF FENNEL

1 LEEK

1 ONION

2 TABLESPOONS OLIVE OIL

568 ML / 1 PINT / 2½ CUPS VEGETABLE STOCK

SALT AND FRESHLY GROUND BLACK PEPPER

50 ML / 2 FL OZ / ¼ CUP DOUBLE CREAM

FEW SPRIGS OF DILL

Trim and finely chop the fennel bulbs. Peel and roughly chop the leek and onion. Heat the olive oil in saucepan. Fry the fennel, leek and onion in the olive oil over a low heat until softened, around 10 minutes. Pour in the stock and bring to the boil. Reduce the heat and simmer for 20 minutes.

Liquidise the soup until smooth. Season with salt and freshly ground pepper to taste. Re-heat and stir in the double cream.

Serve garnished with the sprigs of dill.

ALPHONSE LEGROS *Le Repas des Pauvres* 1877

Speyside Soup

Serves 4

3 SLICES OF WHITE BREAD

6 TABLESPOONS OLIVE OIL

1 ONION

1 LEEK

2 STICKS CELERY

8 TABLESPOONS CHOPPED FRESH DILL

700 G / 1 LB 9 OZ SALMON BONES

3 TABLESPOONS TOMATO PURÉE

125 ML / 4 FL OZ / ½ CUP DRY WHITE WINE

55 G / 2 OZ / ½ CUP CORNFLOUR

50 ML / 2 FL OZ / ¼ CUP DOUBLE CREAM

SALT AND FRESHLY GROUND BLACK PEPPER

Cube the bread. Heat 2 tablespoons of the olive oil and fry the cubes until golden-brown. Set aside.

Peel and chop the onion and leek. Chop the celery. Heat the remaining olive oil in a large saucepan and gently fry the onion, leek, celery and dill until softened. Add the salmon bones and tomato purée. Cover and cook for 5 minutes to draw out the salmon juices. Add the white wine and allow to sizzle for 2–3 minutes. Add 850 ml/1½ pints/3¾ cups water and bring to the boil. Simmer for a maximum of 20 minutes.

Strain the salmon stock through a fine sieve. Return to the heat and bring back to the boil. Mix the cornflour with a little cold water to form a paste and mix into the stock, stirring until thickened. Stir in the double cream and season with salt and freshly ground pepper to taste.

Serve with the croûtons.

Celery and Chestnut Soup

Serves 4

1 HEAD CELERY

1 ONION

1 LEEK

2 TABLESPOONS OLIVE OIL

150 G / 5½ OZ VACUUM-PACKED CHESTNUTS

600 ML / 1 PINT / 2½ CUPS VEGETABLE STOCK

SALT AND FRESHLY GROUND BLACK PEPPER

50 ML / 2 FL OZ / ¼ CUP DOUBLE CREAM

FEW SPRIGS OF FRESH CORIANDER

Trim and chop the celery. Peel and roughly chop the onion and leek. Heat the olive oil in a saucepan and gently fry the celery, onion and leek until softened. Add the chestnuts and stock.

Bring the soup to the boil, reduce the heat and simmer for 20 minutes. Liquidise the soup and pass it through a fine strainer. Season with salt and freshly ground pepper. Stir in the double cream and gently re-heat.

Serve garnished with the sprigs of coriander.

Wild Mushroom Terrine

Serves 8 as a starter

*You will need a 15 × 7.5 × 7.5 cm / 6 × 3 × 3 inch
metal terrine for this recipe.*

1 KG / 2 LB 4 OZ WILD MUSHROOMS (FOR A CHEAPER ALTERNATIVE
USE A MIXTURE OF OYSTER MUSHROOMS, BROWN CAP
MUSHROOMS AND DRIED PORCINI)

1 ONION

BUNCH OF FRESH CORIANDER

115 G / 4 OZ /1 STICK BUTTER

225 ML / 8 FL OZ / 1 CUP DOUBLE CREAM

1 TABLESPOON BRANDY

1 TABLESPOON GREEN AND PINK PEPPERCORNS IN BRINE

FRESHLY GROUND BLACK PEPPER

25 G / 1 OZ LEAF GELATINE

Roughly chop the mushrooms. If using dried porcini soak for 15 minutes in warm water then drain and chop them. Peel and finely chop the onion. Finely chop the coriander.

Melt the butter in a saucepan and sweat the onions until softened. Add the mushrooms and coriander. Mix well and add the double cream, brandy, peppercorns and freshly ground pepper. Cook over a low heat for 15–20 minutes until the mushrooms have softened. Set aside to cool.

Dissolve the gelatine in 2–3 tablespoons of the cooled liquid in which the mushrooms were cooked. Add the dissolved gelatine to the mushrooms, mixing well.

Line a terrine with clingfilm. Pour the mushroom mixture into the tin and cover. Chill for 4 hours until set, or overnight.

To serve, place slices of the terrine on a bed of salad leaves and accompany with slices of toast or warm bread rolls.

Sir William Nicholson *Mushrooms* 1940

Caramelised Onions in Hazelnut Pastry Tarts with Tomato and Basil Sauce

Serves 4 as a starter

Hazelnut Pastry

85 G / 3 OZ / ¾ STICK BUTTER

1 EGG YOLK

175 G / 6 OZ / 1½ CUPS PLAIN FLOUR

PINCH OF SALT

55 G / 2 OZ / ½ CUP GROUND HAZELNUTS

2 TABLESPOONS WATER

Caramelised Onion Filling

4 ONIONS

1 CLOVE GARLIC

3 TABLESPOONS OLIVE OIL

55 G / 2 OZ / ¼ CUP SOFT DARK BROWN SUGAR

4 TABLESPOONS MALT VINEGAR

2 TABLESPOONS CHOPPED CORIANDER

1 TEASPOON GROUND GINGER

150 ML / 5 FL OZ / ⅔ CUP MILK

2 EGGS

SALT AND FRESHLY GROUND BLACK PEPPER

Tomato and Basil Sauce

1 ONION

1 CLOVE GARLIC

450 G / 1 LB TOMATOES OR 1 × 400 G / 14 OZ TIN PEELED, CHOPPED TOMATOES

2 TABLESPOONS OLIVE OIL

2 TABLESPOONS SUN-DRIED TOMATO PURÉE OR TOMATO PURÉE

8 SPRIGS OF FRESH BASIL

SALT AND FRESHLY GROUND BLACK PEPPER

First make the hazelnut pastry: dice the butter. Beat the egg yolk. Sift the flour and salt into a mixing bowl and add in the ground hazelnuts. Mix the diced butter into the flour with your fingertips until the mixture resembles breadcrumbs. Work in the beaten yolk and the water so that the mixture forms a sticky dough. If you have a food processor, blend all the pastry ingredients together until a dough is formed. Wrap the dough in clingfilm and chill for 2 hours.

While the pastry dough is chilling, make the caramelised onion filling and prepare the tomato and basil sauce.

To make the caramelised onions: peel the onions and slice into 5 mm / ¼ in cubes. Peel and crush the garlic. Heat the olive oil in a frying pan and fry the cubed onions until they begin to brown. Add the garlic, sugar, malt vinegar, coriander and ground ginger and cook uncovered over a medium heat, stirring occasionally, until practically all the liquid has evaporated. Remove from the heat and set aside.

To make the tomato and basil sauce: peel and finely chop the onion. Peel and crush the garlic. If you are using fresh tomatoes, briefly scald them in boiling water, then drain, peel and chop them. Heat the olive oil in a saucepan and gently fry the onion and garlic until softened and fragrant. Add the chopped tomatoes and tomato purée. Tear the sprigs of basil and add them to the sauce. Season with salt and freshly ground pepper. Bring to the boil, then reduce the heat and simmer for 10 minutes until slightly thickened. Set aside and heat through as required.

To make the caramelised onion tartlets: pre-heat the oven to Gas Mark 4/180°C/350°F. Roll out the hazelnut pastry on a floured board. Line four 7.5 cm/3 inch fluted tartlet tins with removable bases with the pastry. Prick the base of each pastry case, line with foil and fill with baking beans. Bake blind for 15 minutes. Remove the pastry cases from the oven and remove the foil and baking beans.

Increase the oven temperature to Gas Mark 5/190°C/375°F. Beat together the milk and eggs and season with salt and freshly ground pepper. Fill the tartlet cases with the caramelised onions and pour the egg custard over them. Bake the tartlets for about 30 minutes until the filling is set.

Serve warm from the oven with warm tomato and basil sauce.

Vegetable Filo Parcels with Champagne and Chervil Sauce

Serves 4

For best results use the freshest, best quality vegetables you can find. A good quality dry sparkling wine, such as a Cava, can be substituted for the champagne.

Vegetable Filo Parcels

125 G / 4 OZ CARROTS

1 LEEK

125 G / 4 OZ MANGETOUT

25 G / 1 OZ / ¼ STICK BUTTER

SALT AND FRESHLY GROUND BLACK PEPPER

2 EGG YOLKS

3 SHEETS OF FILO PASTRY

Champagne and Chervil Sauce

2 SHALLOTS

15 G / ½ OZ / ⅛ STICK BUTTER

6 TABLESPOONS CHOPPED CHERVIL PLUS 8 CHERVIL SPRIGS TO GARNISH

1 GLASS CHAMPAGNE OR DRY SPARKLING WINE

150 ML / 5 FL OZ / ⅔ CUP DOUBLE CREAM

SALT AND FRESHLY GROUND BLACK PEPPER

Peel the carrot and slice into short, fine strips. Trim the leek and slice into short, fine strips. Top and tail the mangetout and slice finely.

Melt the butter in a frying pan and gently fry the carrots, leek and mangetout for 3 minutes. Season with salt and freshly ground pepper.

Pre-heat the oven to Gas Mark 5/190°C/375°F. Beat the egg yolks. Cut the filo pastry sheets into twelve 13 × 13 cm (5 × 5 inch) squares. Cover the squares with a damp tea-towel or a sheet of clingfilm to prevent them drying out and becoming brittle. Place three filo squares on top of each other, angled so as to form a 12-pointed star shape, lightly brushing each

DUNCAN GRANT *Still Life with Carrots* c.1921

sheet with the beaten egg yolk as you layer it. Place 1 tablespoon of the vegetable filling in the centre of the filo star. Brush the corners of the star with the egg. Gather up the filo corners and bring them together to form a money-pouch-shaped parcel. Repeat the process with the remaining filo squares and vegetable filling to make four parcels in all.

Bake the parcels for 20–25 minutes until golden-brown.

While the parcels are baking prepare the champagne and chervil sauce: peel and finely chop the shallots. Melt the butter in a frying pan and fry the shallots and chopped chervil over a low heat until softened and fragrant. Add the champagne or sparkling wine and cook uncovered until it is almost completely reduced. Add the double cream and cook uncovered until reduced by a third. Season with salt and freshly ground pepper and strain.

Serve the parcels straight from the oven with the champagne and chervil sauce poured around them. Garnish with the sprigs of chervil.

Poached Pears with Stilton Walnut Quennelles

Serves 4

2 FIRM RIPE DESSERT PEARS

JUICE OF ½ LEMON

100 G / 3½ OZ / ⅓ CUP CASTER SUGAR

1 TABLESPOON MIXED SPICE

1 CINNAMON STICK

75 ML / 2½ FL OZ / ⅓ CUP RED WINE

75 ML / 2½ FL OZ / ⅓ CUP PORT

115 G / 4 OZ STILTON CHEESE

15 G / ½ OZ FRESH DILL

55 G / 2 OZ CHOPPED WALNUTS

FRESHLY GROUND BLACK PEPPER

2–3 TABLESPOONS SINGLE CREAM

Peel the pears, keeping the stalks intact. Remove the cores from the bottom end of the pears with a corer. Rub the pears with the lemon juice and place them in a saucepan. Add the sugar, mixed spice, cinnamon stick, red wine and port. Top up with water until the pears are well covered. Bring to the boil, then reduce the heat and simmer until the pears are tender. Leave them to cool in the syrup, then remove them with a slotted spoon, cover and set aside. Boil the pear syrup until it is reduced by half. Set aside to cool.

Trim the Stilton of any rind and cut into small chunks. Finely chop the dill. Put the Stilton, dill and chopped walnuts in a food processor and blend to make a paste. Season with freshly ground pepper and mix in the single cream.

Slice the cooled pears in half and make four cuts two-thirds the length of the pear in each half. Using two tablespoons, shape the Stilton mixture into four quennelles.

To serve, fan a pear half on a serving plate, place a Stilton quennelle next to it and pour over a little syrup.

WALTER RICHARD SICKERT *Roquefort* c.1918–20

Ogen Melon with Champagne and Cassis

Serves 4

You can use a good quality dry sparkling wine instead of champagne.
If Ogen melons are unobtainable substitute Charentais melons.

2 OGEN MELONS

1 ORANGE

2 GLASSES CHILLED CHAMPAGNE OR DRY SPARKLING WINE

30 ML / 1 FL OZ / 2 TABLESPOONS CASSIS

SPRIGS OF MINT

Halve the melons and scoop out the seeds. Using a melon baller scoop out melon balls.

Peel and slice the orange finely and line four bowls with the slices. Top with melon balls. Mix the champagne or dry sparkling wine with the cassis and pour over the melon balls.

Decorate with the sprigs of mint and serve at once.

Right: STANHOPE ALEXANDER FORBES *The Health of the Bride* 1889 (detail)

Main Courses

Mussels in White Wine

Serves 4

1 ONION

2 STICKS CELERY

1 KG / 2¼ LB MUSSELS

1 TABLESPOON OLIVE OIL

4 SPRIGS OF THYME

1 BAY LEAF

150 ML / 5 FL OZ / ⅔ CUP DRY WHITE WINE

150 ML / 5 FL OZ / ⅔ CUP DOUBLE CREAM

55 G / 2 OZ / ½ STICK BUTTER

Peel and chop the onion. Chop the celery. Wash and scrub the mussels in cold water, removing any beards. Discard any mussels that float or are already open.

Heat the olive oil in a large, thick-bottomed pan and briefly cook the onion, celery, thyme and bay leaf. Add the mussels. Add the white wine, cover and boil for 5 minutes. Remove the mussels with a slotted spoon and discard any that failed to open during cooking.

Boil the liquid until it has reduced by two-thirds. Add the double cream and boil fast until the sauce thickens. Remove from the heat and stir in the butter. Pour the cream sauce over the mussels and serve immediately.

Right: MARCEL BROODTHAERS *Casserole and Closed Mussels* 1964

Fresh Lobster Salad

Serves 4

1 ONION

4 STICKS CELERY

1 BAY LEAF

1 TABLESPOON MALT VINEGAR

2 × 900 G / 2 LB LIVE LOBSTERS

SALT AND FRESHLY GROUND BLACK PEPPER

125 G / 4 OZ ASSORTED SALAD LEAVES

2 TABLESPOONS CAPERS IN BRINE

2 LEMONS

MAYONNAISE

Peel and quarter the onion. Roughly chop the celery. Place the onion, celery, bay leaf and malt vinegar in a large saucepan and add enough water to cover the lobsters when they are added. Bring the water to the boil. Plunge the lobsters head first into the water and boil for 15–20 minutes. Remove the lobsters from water and set aside to cool.

When the lobsters are cool, slice them in half from head to tail. Remove the tail meat (discard the intestinal vein running down its centre) and claw meat and season with salt and freshly ground pepper. Reserve. Carefully wash out the lobster shells.

To assemble the dish, place the salad leaves and lobster meat in the four shells. Sprinkle with the capers.

Slice the lemons into wedges and serve on the side along with four portions of mayonnaise.

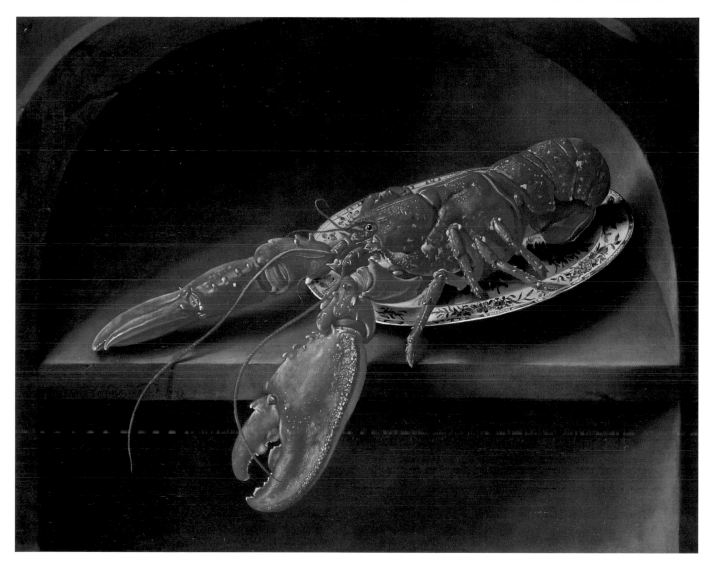

CHARLES COLLINS *Lobster on a Delft Dish* 1738

Sole, Spinach and Prawn Parcels with White Wine Sauce

Serves 4

125 G / 4 OZ SPINACH

55 G / 2 OZ CREAM CHEESE

FRESHLY GRATED NUTMEG

SALT AND FRESHLY GROUND BLACK PEPPER

125 G / 4 OZ COOKED PEELED PRAWNS

280 G / 10 OZ PUFF PASTRY

1 EGG

4 × 125 G / 4 OZ LEMON SOLE FILLETS

White Wine Sauce

1 ONION

1 TABLESPOON OLIVE OIL

4 TABLESPOONS CHOPPED DILL

450 G / 1 LB FISH BONES

150 ML / 5 FL OZ / ⅔ CUP DRY WHITE WINE

3 TABLESPOONS DOUBLE CREAM

15 G / ½ OZ / ⅛ STICK BUTTER

SALT AND FRESHLY GROUND BLACK PEPPER

Wash the spinach and cook in a covered saucepan with a tablespoon of water until wilted. Drain, cool and squeeze dry. Purée the spinach and cream cheese in a food processor. Season with the nutmeg, salt and freshly ground pepper. Mix in the prawns.

Pre-heat the oven to Gas Mark 5/190 °C/375 °F. Roll out the puff pastry. Cut out four 10 × 7.5 cm/4 × 3 inch rectangles. Beat the egg.

Pat the sole fillets dry and season with salt and freshly ground pepper. Divide the prawn and spinach mixture into four portions and spread a portion over the centre of each fillet. Carefully roll up each fillet into a cigar shape. Wrap each rolled fillet in a puff pastry rectangle, brushing the edges with the beaten egg and sealing tightly. Brush the parcels with the beaten egg and bake for 30 minutes until golden-brown.

While the parcels are baking make the white wine sauce: peel and chop the onion. Heat the olive oil in a large saucepan and fry the onion with the dill until softened. Add the fish bones, cover and heat through. Pour in the wine and sizzle briefly, then add 300 ml/10 fl oz/1¼ cups cold water. Bring to the boil, cover and cook for 5 minutes. Strain the stock, then boil it until it is reduced by half. Remove from the heat, mix in the double cream and heat through. Add the butter and heat until it has melted; do not let the sauce boil again. Season to taste with salt and freshly ground pepper.

Serve each parcel with a little white wine sauce poured around its base.

WILLIAM COLLINS *Prawn Fishing* 1828

WILLIAM SCOTT *Mackerel on a Plate* 1951–2

Poached Trout with Mousseline Sauce

Serves 4

1 ONION

2 STICKS CELERY

2 EGG YOLKS

50 ML / 2 FL OZ / ¼ CUP WHITE WINE VINEGAR

4–5 SPRIGS OF DILL

6 BLACK PEPPERCORNS

4 RAINBOW TROUT, CLEANED AND GUTTED

225 G / 8 OZ / 2 STICKS UNSALTED BUTTER

4 TABLESPOONS FINELY CHOPPED FRESH TARRAGON

125 ML / 4 FL OZ / ⅓ CUP DOUBLE CREAM

SALT

Peel and roughly chop the onion. Chop the celery. Melt the butter. Beat the egg yolks.

Fill a large saucepan with enough water to cover the four trout. Add the vinegar, onion, celery, dill and peppercorns. Bring to the boil then reduce the heat to a simmer. Add the trout and cook for 8–10 minutes until they feel firm. Remove them with a slotted spoon and set aside.

Boil the vinegar water, reducing it considerably until it becomes syrupy. Strain at once into a food processor. Add the beaten egg yolks and gradually add the melted butter in stages, mixing as you do so. Mix in the chopped tarragon and double cream. Season to taste with salt.

Serve the trout with the mousseline sauce.

Seafood Crêpes

Serves 4

Crêpes

115 G / 4 OZ / 1 CUP FLOUR

PINCH OF SALT

2 EGGS

150 ML / 5 FL OZ / ⅔ CUP MILK

BUTTER FOR FRYING

Seafood Filling

85 G / 3 OZ SALMON FILLET

85 G / 3 OZ MONKFISH FILLET

½ ONION

55G / 2 OZ BUTTON MUSHROOMS

2 TABLESPOONS OLIVE OIL

4 TABLESPOONS CHOPPED DILL

55 G / 2 OZ COOKED PEELED PRAWNS

150 ML / 5 FL OZ / ⅔ CUP DRY WHITE WINE

SALT AND FRESHLY GROUND BLACK PEPPER

175 ML / 6 FL OZ / ¾ CUP DOUBLE CREAM

2 EGG YOLKS

First prepare the crêpes: sift the flour and salt into a mixing bowl. Break the eggs into the flour and gradually beat in the milk to form a batter. Heat a portion of butter in a small frying pan until sizzling. Pour in a ladleful of the batter, tip the pan to spread it evenly and fry until set. Turn the crêpe over and fry for a further couple of minutes. Remove. Repeat the process to make eight crêpes in all.

To make the seafood filling: finely dice the salmon and monkfish. Peel and finely chop the onion and button mushrooms. Heat the olive oil in a frying pan and fry the onion, mushrooms and dill until the onion has softened. Add the salmon, monkfish and prawns and heat through. Pour in the white wine and sizzle briefly. Reduce the heat and simmer for 2–3 minutes until the seafood is cooked though. Season with salt and freshly

GEORGES BRAQUE *Bottle and Fishes* c.1910–12

ground pepper. Remove the seafood with a slotted spoon. Boil the remaining liquid uncovered until it has reduced by half and is syrupy. Remove from the heat and mix in 125 ml/4 fl oz/½ cup of the double cream. Return to the heat and gently heat through. Carefully mix a spoonful of the cream sauce with the seafood.

Pre-heat the oven to Gas Mark 5/190°C/375°F. To assemble the dish, divide the seafood into eight portions. Place a portion on each crêpe and roll the crêpes up over the seafood. Place the filled crêpes in a heatproof serving dish. Bake for 10–15 minutes until heated through. Whip the remaining double cream until stiff. Beat the egg yolks. Mix the remaining cream sauce with the beaten yolks and whipped cream. Pre-heat the grill. Cover the crêpes with the cream sauce and glaze under the grill for 2–3 minutes.

Serve at once.

Salmon, Mushrooms and Rice in Puff Pastry

Serves 4

200 G / 7 OZ PUFF PASTRY

1 EGG YOLK

25 G / 1 OZ BUTTON MUSHROOMS

1 SHALLOT

225 G / 8 OZ SALMON FILLET

1 TABLESPOON OLIVE OIL

25 G / 1 OZ / ¼ STICK BUTTER

2 TABLESPOONS WHITE WINE

125 ML / 5 FL OZ / ⅔ CUP DOUBLE CREAM

SALT AND FRESHLY GROUND BLACK PEPPER

55 G / 2 OZ COOKED RICE

4 SPRIGS OF CHERVIL

Pre-heat the oven to Gas Mark 5/190 °C/375 °F. Roll out the puff pastry and trim it to a 23 cm/9 inch square. Cut the pastry into four even-sized squares. Beat the egg yolk. Take one pastry square and lightly mark a second square inside it to give a 1 cm/½ inch border. Leaving two diagonally opposite corners intact, cut along the lightly marked square. Brush the pastry with the beaten egg. Fold the two outer corners of the cut-through sides over so that they meet the inside corners opposite and thus form a pastry box. Press the edges together and brush with the beaten egg. Repeat the process to make four pastry boxes in all. Bake the boxes for 15 minutes until risen and golden-brown.

While the pastry boxes are baking prepare the salmon filling: peel and finely chop the mushrooms and shallot. Dice the salmon. Heat the olive oil and 15 g/½ oz/⅛ stick of the butter in a frying pan. Fry the shallot until softened, then add the mushrooms, salmon, white wine, double cream and salt and freshly ground pepper. Simmer gently for 10 minutes, stirring occasionally. Remove the salmon, mushrooms and shallot with a slotted spoon and reserve. Reduce the sauce by half, remove it from the

heat and whisk in the remaining butter. Carefully mix the salmon mixture into the sauce and gently warm through.

Fill each of the warm pastry boxes with a layer of cooked rice followed by a layer of the salmon mixture.

Top each box with a sprig of chervil and serve at once.

ALAN REYNOLDS *Summer: Young September's Cornfield* 1954

Breast of Pheasant with Pâté Croûtons and Madeira Sauce

Serves 4

Pâté

1 SHALLOT

25 G / 1 OZ / ¼ STICK BUTTER

55 G / 2 OZ CHICKEN LIVERS

25G / 1 OZ MINCED PORK

50 ML / 2 FL OZ / ¼ CUP BRANDY

2 TABLESPOONS DOUBLE CREAM

SALT AND FRESHLY GROUND BLACK PEPPER

Madeira Sauce

2 SLICES OF BACON

1 ONION

1 CARROT

1 STICK CELERY

1 TABLESPOON OLIVE OIL

1 BAY LEAF

125 ML / 4 FL OZ / ½ CUP MADEIRA

150 ML / 5 FL OZ / ⅔ CUP VEAL OR BEEF STOCK

2 TABLESPOONS OLIVE OIL

4 BREAST FILLETS OF PHEASANT

SALT AND FRESHLY GROUND BLACK PEPPER

4 SLICES OF FRENCH BREAD

1 TABLESPOON GARLIC BUTTER

15 G / ½ OZ / ⅛ STICK BUTTER

First make the pâté: peel and finely chop the shallot. Melt the butter in a frying pan and gently fry the shallot until softened. Add the chicken livers and minced pork and fry over a medium heat until cooked through. Add the brandy and cream and cook, stirring, until the liquid has

VANESSA BELL *Pheasants* 1931

evaporated. Season with salt and freshly ground pepper. Put in a food processor and blend to a paste.

Prepare the Madeira sauce: shred the bacon. Peel and finely chop the onion and carrot. Finely chop the celery. Heat the olive oil in a saucepan and fry the bacon, onion, carrot, celery and bay leaf until the onion has softened and the mixture is fragrant. Pour in the Madeira and stock and season with salt and freshly ground pepper. Boil until the liquid has reduced by three-quarters. Set aside until required.

To prepare the pheasant breasts: heat the 2 tablespoons of olive oil in a large frying pan and fry the pheasant breasts for 6 minutes on each side. Season with salt and freshly ground pepper.

While the pheasant breasts are frying, spread the French bread slices with the garlic butter and grill until golden. Spread each slice with a portion of the pâté.

Just before serving, bring the Madeira sauce to the boil again then remove from the heat and stir in the butter until melted.

To serve, place a pheasant breast on each slice of French bread and pour a little of the Madeira sauce over it.

Hindle Wakes

This poultry recipe from Lancashire dates back to medieval times and is also known as Hen de la Wake. Ask your butcher to bone a 1.3 kg / 3 lb chicken. This recipe requires a length of muslin cloth.

Serves 4

1 ONION

1 TABLESPOON OLIVE OIL

6 TABLESPOONS FRESH BREADCRUMBS

4 TABLESPOONS CHOPPED FRESH SAGE

4 TABLESPOONS CHOPPED FRESH THYME

4 TABLESPOONS CHOPPED FRESH OREGANO

150 ML / 5 FL OZ / ⅔ CUP CHICKEN STOCK

125 G / 4 OZ PITTED PRUNES

SALT AND FRESHLY GROUND BLACK PEPPER

1 × 1.3 KG / 3 LB CHICKEN, BONED

55 G / 2 OZ / ⅓ CUP DARK BROWN SUGAR

150 ML / 5 FL OZ / ⅔ CUP MALT VINEGAR

Peel and finely chop the onion. Heat the olive oil in a saucepan and gently fry the onion until softened. Remove from the heat and mix in the breadcrumbs, sage, thyme and oregano. Add 5–6 tablespoons of the chicken stock and mix to make a soft paste. Mix in the prunes. Season with salt and freshly ground black pepper.

Pre-heat the oven to Gas Mark 6/200°C/400°F. Lay the chicken out on the muslin cloth and season with salt and pepper. Slice the chicken lengthwise along its underside and place the prune mixture along its middle. Roll the chicken up lightly in the muslin cloth and tie each end with string. Tie three lengths of string along the length of the bird.

Place the chicken in a large ovenproof pot. Add the remaining stock and the sugar, vinegar and enough water to cover the chicken. Cover and cook in the oven for 1½ hours until cooked through. Remove the chicken and allow it to cool, then remove the cloth and cut the chicken into slices.

Feta-filled Breasts of Chicken with Tomato, Olive and Anchovy Sauce

Serves 4

55 G / 2 OZ FETA CHEESE

2 CLOVES GARLIC

8 SPRIGS OF BASIL

6 TABLESPOONS OLIVE OIL

4 BONELESS CHICKEN BREASTS

SALT AND FRESHLY GROUND BLACK PEPPER

8 SPINACH LEAVES

225 G / 8 OZ FRESH PLUM TOMATOES

1 ONION

25 G / 1 OZ PITTED BLACK OLIVES

4 ANCHOVY FILLETS

1 TABLESPOON TOMATO PURÉE

125 ML / 4 FL OZ / ½ CUP DRY WHITE WINE

Finely dice the feta cheese. Peel and chop 1 clove of garlic. Purée the garlic, basil and 1½ tablespoons of the olive oil in a food processor. Mix the basil purée with the feta cheese. Cover and marinate in the refrigerator for 30 minutes.

Carefully slice the chicken breasts into two lengthwise, using a large, extremely sharp knife. Season with salt and freshly ground pepper.

Briefly cook the spinach leaves in ½ tablespoon of the olive oil until barely wilted. Place a spinach leaf on each chicken slice and top with the marinated feta cheese. Carefully roll up each chicken slice lengthwise and skewer with cocktail sticks.

Scald the tomatoes in boiling water, then drain, peel and chop them. Peel and chop the onion. Roughly chop the olives. Finely chop the anchovy fillets. Peel and chop the remaining garlic clove.

Heat 3 tablespoons of the olive oil in large frying pan and fry the stuffed chicken breasts for 15 minutes over medium heat, turning often, until they are browned on all sides and cooked through.

Meanwhile make the tomato, olive and anchovy sauce: fry the garlic and onion in the remaining olive oil until fragrant. Add the chopped tomatoes, tomato purée, chopped olives, anchovy fillets and white wine. Season with salt and freshly ground pepper, bearing in mind the saltiness of the anchovies. Bring to the boil and cook uncovered for 15 minutes, stirring now and then, until the sauce has reduced and thickened.

To serve, spoon the tomato, olive and anchovy sauce on to four serving plates and place two pieces of chicken on each plate, removing the cocktail sticks.

RAOUL DUFY *Olive Trees by the Golfe Juan* c.1927

Veal and Apricot Galantine
This recipe requires a length of muslin cloth.

Serves 8 as a starter

225 G / 8 OZ SEMI-DRIED APRICOTS

450 G / 1 LB FINELY MINCED VEAL

125 G / 4 OZ WHITE BREADCRUMBS

6 TABLESPOONS CHOPPED FRESH TARRAGON

SALT AND FRESHLY GROUND BLACK PEPPER

3 EGG YOLKS

200 ML / 10 FL OZ / 1¼ CUPS DOUBLE CREAM

50 ML / 2 FL OZ / ¼ CUP BRANDY

1 TABLESPOON DARK BROWN SUGAR

1 TABLESPOON VINEGAR

Pre-heat the oven to Gas Mark 5/190°C/375°F. Roughly chop the apricots and mix them with the veal and breadcrumbs. Mix in the tarragon and season well with salt and freshly ground pepper. Mix in the egg yolks, double cream and brandy. Shape the mixture into a sausage shape. Wrap with a muslin cloth, loosely enough to allow the galantine to swell. Tie firmly at either end.

Place the galantine in a large ovenproof pan. Cover with cold water and stir in the dark brown sugar, vinegar and 1 teaspoon salt. Cover and cook for 1¾ to 2 hours. Remove the galantine from the water and leave to cool before unwrapping it. Chill until ready to serve.

To serve, place slices of the galantine on a bed of salad leaves and accompany with toast or warm bread rolls.

Veal Kidneys Florentine

Serves 4

225 G / 8 OZ VEAL KIDNEYS

1 ONION

225 G / 8 OZ FRESH SPINACH

1 TABLESPOON OIL

1 TEASPOON GROUND MACE

SALT AND FRESHLY GROUND BLACK PEPPER

25 G / 1 OZ SULTANAS

1 TABLESPOONS TOMATO PURÉE

300 ML / 10 FL OZ / 1¼ CUPS BEEF STOCK

15 G / ½ OZ / ⅛ STICK BUTTER

2 TABLESPOONS FLOUR

1 EGG

225 G / 8 OZ PUFF PASTRY

Snip the kidney lobes away from the cores and dice. Peel and finely chop the onion. Wash and shred the spinach.

Heat the oil in a large frying pan and fry the onion until softened. Add the kidneys and season with the mace and salt and freshly ground pepper. Fry until the kidneys are sealed. Add the sultanas, spinach, tomato purée and beef stock. Bring to the boil and simmer uncovered for 20 minutes, stirring occasionally. Meanwhile, melt the butter and mix it with the flour. Add this to the kidneys when they have cooked for 20 minutes. Stir it in well then simmer for 10 minutes until the liquid has thickened. Set the kidney mixture aside to cool.

Pre-heat the oven to Gas Mark 5/190°C/375°F. Beat the egg. Roll out the puff pastry and cut out four 10 cm/4 inch circles and four 15 cm/ 6 inch circles. Divide the kidney mixture into four portions. Place a portion in the centre of a 10 cm/4 inch circle. Brush the edges with the beaten egg. Top with a 15 cm/6 inch circle and press down firmly, making sure no air bubbles are trapped. Brush with the beaten egg. Repeat the process to make four pastry parcels in all. Bake for 20 minutes until golden-brown.

Medallions of Pork
with Ginger Beer Sauce

Serves 4

½ ONION

1 CLOVE GARLIC

1 STICK CELERY

1 CARROT

1 PARSNIP

1 CM / ½ INCH PIECE OF ROOT GINGER

4 BONELESS PORK LEG STEAKS

SALT AND FRESHLY GROUND BLACK PEPPER

2 TABLESPOONS FLOUR

25 G / 1 OZ / ¼ STICK BUTTER

2 TABLESPOONS OLIVE OIL

175 ML / 6 FL OZ / ¾ CUP GINGER BEER

300 ML / 10 FL OZ / 1¼ CUPS MEAT OR VEGETABLE STOCK

4 SPRIGS OF THYME

6 TABLESPOONS CHOPPED CORIANDER

4 TABLESPOONS GREEK YOGHURT

Pre-heat the oven to Gas Mark 5/190°C/375°F. Peel and finely chop the onion and garlic. Cut the celery into short, narrow lengths. Peel the carrot and parsnip and cut into short, narrow strips. Peel and crush the root ginger.

Season the pork steaks with salt and freshly ground pepper and toss them in the flour. Heat the butter and olive oil in a casserole dish and fry the pork for 5 minutes on each side. Add the chopped onion, garlic and ginger and fry briefly until fragrant. Add the celery, carrot and parsnip and cook for 3 minutes, stirring often. Add the ginger beer, stock, thyme and 2 tablespoons of the chopped coriander, mixing well. Cover the casserole and place in the oven for 30 minutes.

To serve, stir in the yoghurt and remaining coriander.

CAMILLE PISSARO *The Pork Butcher* 1883

Ham and Herbed Cream Cheese Buckwheat Pancake Gâteau

Serves 4

115 G / 4 OZ / 1 CUP BUCKWHEAT FLOUR

SALT AND FRESHLY GROUND BLACK PEPPER

4 EGGS

300 ML / 10 FL OZ / 1¼ CUPS MILK

6 TABLESPOONS CHOPPED FRESH CORIANDER

3 TABLESPOONS TORN BASIL

3 TABLESPOONS CHOPPED FRESH THYME

15 G / ½ OZ / ⅛ STICK BUTTER

300 G / 10½ OZ CREAM CHEESE

2 TABLESPOONS SUN-DRIED TOMATO PURÉE

12 SLICES OF SMOKED HAM

SPRIGS OF CHERVIL

Sift the buckwheat flour into a bowl. Season with salt and freshly ground pepper. Break the eggs into the flour and gradually beat in the milk to form a thick batter. Mix in a tablespoon each of the coriander, basil and thyme.

Heat a 23 cm/9 inch frying pan greased with a little butter. When it is hot, pour in a ladleful of the batter. Tilt the pan to spread it evenly and fry until set. Turn the pancake over and fry for another 1–2 minutes. Remove from pan. Repeat the process to make six pancakes in all.

Mix the cream cheese with the remaining coriander, basil and thyme, in a food processor or by hand. Mix half the herbed cream cheese with the sun-dried tomato purée.

Line a 23 cm/9 inch cake tin with a removable base with siliconised baking parchment. Place a buckwheat pancake on its base and spread the pancake with a layer of herbed cream cheese. Top with two slices of ham. Place a second buckwheat pancake over this and spread it with a layer of the herbed cream cheese that has been combined with sun-dried tomato purée. Top with two slices of ham. Repeat the process until all the pancakes and cream cheese mixtures have been used, ending with a layer of herbed cream cheese combined with sun-dried tomato purée. Cover and chill until ready to serve.

Serve slices of the gâteau garnished with sprigs of chervil.

Parmesan Crumb Lamb Steaks with Caper Sauce

Serves 4

Caper Sauce

1 SHALLOT

1 CARROT

1 STICK CELERY

1 TABLESPOON OLIVE OIL

1 BAY LEAF

1 TEASPOON TOMATO PURÉE

125 ML / 4 FL OZ / ½ CUP RED WINE

150 ML / 5 FL OZ / ⅔ CUP LAMB OR BEEF STOCK

2 TABLESPOONS CAPERS

Parmesan Crumb Lamb Steaks

25 G / 1 OZ FRESH BREADCRUMBS

25 G / 1 OZ / ¼ STICK BUTTER

4 BONELESS LAMB STEAKS

SALT AND FRESHLY GROUND BLACK PEPPER

25 G / 1 OZ FRESHLY GRATED PARMESAN CHEESE

GRATED ZEST OF 1 LEMON

4 TABLESPOONS CHOPPED FRESH PARSLEY

First prepare the caper sauce: peel and finely chop the shallot and carrot. Finely chop the celery. Heat the olive oil in a frying pan and gently fry the shallot, carrot and celery until softened. Add the bay leaf and tomato purée and fry for 3 minutes. Add the red wine and stock and boil until the liquid has reduced by two-thirds. Mix in the capers and heat through.

Meanwhile, prepare the Parmesan crumbed lamb steaks: fry the breadcrumbs in half of the butter until golden-brown. Season the lamb steaks with salt and freshly ground pepper. Grill until cooked to taste. Sprinkle the breadcrumbs and Parmesan cheese over the steaks and dot with the remaining butter. Return to the grill and cook until the Parmesan has melted. Sprinkle with the lemon zest and parsley.

Serve the lamb steaks at once with the caper sauce poured around them.

Steak, Kidney and Mushroom Pie

Serves 4

1 ONION

450 G / 1 LB CHUCK STEAK

225 G / 8 OZ OX KIDNEY

225 G / 8 OZ BUTTON MUSHROOMS

2 TABLESPOONS OLIVE OIL

SALT AND FRESHLY GROUND BLACK PEPPER

1 TABLESPOON TOMATO PURÉE

DASH OF WORCESTERSHIRE SAUCE

600 ML / 1 PINT / 2½ CUPS BEEF STOCK

55 G / 2 OZ / ½ STICK BUTTER

55 G / 2 OZ / ½ CUP FLOUR

175 G / 6 OZ PUFF PASTRY

1 EGG

Peel and chop the onion. Cube the chuck steak and ox kidney. Halve the mushrooms.

Heat the olive oil in a large saucepan and fry the onion and meat until the onion has softened and the meat has browned. Season with salt and freshly ground pepper. Add the mushrooms, tomato purée, Worcestershire sauce and stock. Bring to the boil, then reduce the heat and simmer until the meat is tender, about 1½ hours.

Pre-heat the oven to Gas Mark 4/180°C/350°F. Melt the butter and mix with the flour. Add the flour mixture to the simmering meat. Cook for 10 minutes until the stock has thickened. Pour the meat into a deep pie dish. Roll out the puff pastry. Cut out a pastry 'lid' for the pie dish and a long strip of pastry. Beat the egg. Dampen the edge of the pie dish and press the pastry strip on to the edge. Dampen the pastry strip and press the pastry lid on to it, sealing the edges well. Brush the pastry lid with beaten egg and cut a small steam-hole. Bake the pie for 30 minutes until golden-brown.

MARCEL BROODTHAERS *The Farm Animals* 1974

Roast Beef with Yorkshire Pudding

Serves 4

2 TABLESPOONS WHOLE PEPPERCORNS

900 G / 2 LB SIRLOIN OF BEEF

SEA SALT

2 TABLESPOONS VEGETABLE OIL

600 ML / 1 PINT / 2½ CUPS BEEF STOCK

Yorkshire Pudding

115 G / 4 OZ / 1 CUP PLAIN FLOUR

1 EGG

300 ML / 10 FL OZ / 1¼ CUPS MILK

SALT

1 TABLESPOON VEGETABLE OIL OR DRIPPING

Pre-heat the oven to Gas Mark 5/190°C/375°F. Crush the peppercorns. Season the beef with the sea salt and crushed peppercorns and coat with the vegetable oil.

Make the Yorkshire pudding: sift the flour into a mixing bowl. Break in the egg and beat in the milk to make a thick batter. Season with salt and leave to stand while the beef roasts.

Place the beef on a rack in a roasting tin and roast for 1 hour for rare meat, 1 hour 10 minutes for medium-rare and 1½ hours for well-done meat, basting often. When the beef is cooked to taste, remove it from the oven, cover it with foil and leave to stand in a warm place while the Yorkshire pudding cooks.

Increase the oven temperature to Gas Mark 7/220°C/425°F. Grease a Yorkshire pudding tray with the vegetable oil or dripping. Place the tray in the oven until the oil or dripping is piping hot. Pour the batter into the tray and return to the oven. Cook for 15–20 minutes until the Yorkshire pudding has risen and is golden-brown.

Meanwhile make the gravy with the juices in the roasting tin: heat the beef stock in a saucepan. Spoon off excess fat in the tin leaving the roasting juices. Add the hot stock to the juices and cook over a medium heat until the gravy is reduced by half.

William Hogarth *O the Roast Beef of Old England ('The Gate of Calais')* 1748 (detail)

Beef in Guinness

Serves 4

1 ONION

2 CARROTS

1 STICK CELERY

350 G / 12 OZ CUBED TOPSIDE OF BEEF

440 ML / 15 FL OZ CAN OF GUINNESS

1 TABLESPOON WORCESTERSHIRE SAUCE

SALT AND FRESHLY GROUND BLACK PEPPER

4 SPRIGS OF THYME

1 TEASPOON DRIED OREGANO

55 G / 2 OZ MUSHROOMS

25 G / 1 OZ / ¼ CUP FLOUR

2 TABLESPOONS OLIVE OIL

1 TABLESPOON TOMATO PURÉE

300 ML / 10 FL OZ / 1¼ CUPS BEEF STOCK

Peel and chop the onion. Peel the carrots and slice them into short batons. Slice the celery into short, fine strips. Combine the beef, onion, carrots, celery, Guinness, Worcestershire sauce, salt, freshly ground pepper, thyme and oregano in a bowl. Cover and leave to marinate in the refrigerator overnight.

Quarter the mushrooms. Remove the beef, vegetables and herbs from the marinade, reserving the liquid. Pat the beef cubes dry and roll them in the flour.

Pre-heat the oven to Gas Mark 5/190°C/375°F. Heat the olive oil in a casserole and brown the beef all over. Add the marinated vegetables and herbs and cook for 3 minutes. Stir in the tomato purée. Add in the reserved marinade and the beef stock and mushrooms. Bring to the boil. Cover and cook in the oven for 1 hour until tender.

Check the seasoning and serve.

Left: FERNAND LÉGER *Still Life with a Beer Mug* 1921–2

Fillet of Beef Camargo with Truffle Sauce

Serves 4

1½ ONIONS

1 CLOVE GARLIC

3 TABLESPOONS OLIVE OIL

55 G / 2 OZ CHICKEN LIVERS

1 TABLESPOON CHOPPED CORIANDER

1 TABLESPOON BRANDY

75 ML / 2½ FL OZ / ⅓ CUP DOUBLE CREAM

4 × 140 G / 5 OZ FILLET STEAKS

10 G / ¼ OZ TRUFFLE PASTE

1 CARROT

SALT AND FRESHLY GROUND BLACK PEPPER

1 BAY LEAF

125 ML / 4 FL OZ / ½ CUP MADEIRA

125 ML / 4 FL OZ / ½ CUP BEEF STOCK

25G / 1 OZ / ¼ STICK BUTTER

SPRIGS OF CHERVIL

Heat 1 tablespoon of olive oil and fry the chopped half-onion and garlic until softened. Add the chicken livers and coriander and fry until the livers are cooked. Add the brandy and sizzle briefly. Remove from the heat and cool. Process with 1 tablespoon of cream to make a paste.

Cut a circle of meat from the centre of each steak. Finely chop the meat circles. Mix the chopped meat with the remaining double cream, half the liver paste and half the truffle paste. Fill the holes in the steaks, pressing in firmly. Cover and refrigerate for 1 hour.

Heat 1 tablespoon of oil, season the steaks and fry until brown. Remove, cover and keep warm. Heat the remaining oil in the same pan and fry the chopped onion, carrot and bay leaf for 2–3 minutes. Add the Madeira and stock and the remaining liver and truffle pastes. Cook until the sauce reduces by half. Remove from the heat and whisk in the butter.

Divide the sauce between four serving plates and top with the steaks. Garnish with the sprigs of chervil and serve at once.

Noodles with Wild Mushroom Brandy Cream Sauce

If fresh wild mushrooms are not available substitute field mushrooms.

Serves 4

25 G / 1 OZ DRIED PORCINI MUSHROOMS

350 G / 12 OZ FRESH WILD MUSHROOMS

2 ONIONS

6 SPRIGS OF FRESH THYME

SMALL BUNCH OF FRESH CORIANDER

3 TABLESPOONS OLIVE OIL

2 TABLESPOONS PAPRIKA

SALT AND FRESHLY GROUND BLACK PEPPER

3 TABLESPOONS SUN-DRIED TOMATO PURÉE OR TOMATO PURÉE

50 ML / 2 FL OZ / ¼ CUP BRANDY

125 ML / 4 FL OZ / ½ CUP CRÈME FRAÎCHE OR SOURED CREAM

450 G / 1 LB FRESH TAGLIATELLE

Soak the dried porcini in hot water for 1 hour. Strain and reserve both the soaked porcini and the porcini water. Wash and roughly chop the fresh wild mushrooms. Peel and finely chop the onions. Chop the thyme and coriander.

Heat the olive oil in a frying pan and gently fry the onions until softened. Add the thyme, coriander and paprika and fry, stirring often, for 5 minutes. Add the soaked porcini and fresh mushrooms. Season with salt and freshly ground pepper. Mix in the sun-dried tomato purée or tomato purée and add the brandy. Mix well and cook for a further 5 minutes.

Meanwhile, boil the porcini water in a small saucepan until it has reduced by two-thirds then mix in the crème fraîche or soured cream. Add to the mushroom mixture. Mix well and simmer gently, stirring often.

Cook the tagliatelle in a large saucepan of boiling, salted water until just tender. Strain and serve with the wild mushroom sauce.

Brie, Spinach and Calvados Pancakes

The Calvados jelly needs to set overnight.

Serves 4

Calvados Jelly
4 LEAVES OF LEAF GELATINE
175 ML / 6 FL OZ / ¾ CUP APPLE JUICE
175 ML / 6 FL OZ / ¾ CUP SWEET WHITE WINE
75 ML / 2½ FL OZ / ⅓ CUP CALVADOS

Pancakes
115 G / 4 OZ / 1 CUP PLAIN FLOUR
PINCH OF SALT
2 EGGS
150 ML / 5 FL OZ / ⅔ CUP MILK
BUTTER FOR FRYING

Spinach and Brie Filling
450 G / 1 LB FRESH SPINACH
125 G / 4 OZ BRIE
2 TABLESPOONS OLIVE OIL
PINCH OF GROUND NUTMEG
PINCH OF GROUND GINGER
SALT AND FRESHLY GROUND BLACK PEPPER

Make the Calvados jelly: soften the gelatine in 2–3 tablespoons of the apple juice. Meanwhile heat together the white wine, remaining apple juice and Calvados. When the mixture is very hot add the soaked gelatine and stir briskly until dissolved. Cool and refrigerate overnight until the jelly sets.

Make the pancakes: sift the flour and salt into mixing bowl. Break in the eggs then beat in the milk until a batter is formed. Melt a small cube of butter in a small frying pan until very hot. Pour in a ladleful of batter, tilt the pan to spread it evenly and fry until set. Turn the pancake over and brown it briefly. Remove from the pan. Repeat the process to make eight pancakes in all.

Pre-heat the oven to Gas Mark 5/190°C/375°F, then make the spinach and Brie filling: carefully pick through and wash the spinach. Squeeze it dry of any excess water. Dice the Brie. Heat the olive oil in a frying pan. Add the spinach and season with the nutmeg, ginger, salt and freshly ground pepper. Fry for 2–3 minutes. Remove from the heat and cool for 2–3 minutes. Mix the Brie into the spinach.

Divide the spinach mixture between the pancakes and roll each pancake over its spinach filling. Place the rolled pancakes in an ovenproof dish and bake for 5–10 minutes until heated through.

Serve the pancakes accompanied with the Calvados jelly.

SIR STANLEY SPENCER *Apple Gatherers* 1912–13

Omelette Arnold Bennett

Serves 4

½ ONION

85 G / 3 OZ COOKED SMOKED HADDOCK

55G / 2 OZ PARMESAN OR CHEDDAR CHEESE

2 TABLESPOONS DOUBLE CREAM

150 ML / 5 FL OZ / ⅔ CUP MILK

PINCH OF GROUND NUTMEG

SALT AND FRESHLY GROUND BLACK PEPPER

70G / 2½ OZ / ⅝ STICK BUTTER

1 TABLESPOON FLOUR

2 EGG YOLKS

12 EGGS

10 SPRIGS OF CHERVIL

Peel and finely chop the onion. Flake the haddock, removing any skin and bones. Grate the Parmesan cheese. Whip the double cream.

Place the milk in a saucepan with a tablespoon of the chopped onion, and the nutmeg, salt and freshly ground pepper and bring to the boil. In a separate saucepan melt 25 g/1 oz/¼ stick of the butter. Stir in the flour and cook, stirring, for 1–2 minutes. Meanwhile strain the milk. Gradually stir the infused milk into the flour mixture. Bring it to the boil while stirring until it thickens into a white sauce. Mix in 25 g/1 oz of the cheese until it melts. Allow the sauce to cool then mix in the 2 egg yolks and whipped cream.

Melt 15 g/½ oz/⅛ stick of the butter in a saucepan and fry the remaining onion until softened. Add the haddock and cook for 2–3 minutes. Mix the onion and haddock with 4 tablespoons of the cheese sauce.

Beat the eggs and season them with salt and freshly ground black pepper. Heat the remaining butter in a large frying pan until foaming. Pour in the beaten eggs and make a large omelette. Turn the omelette on to a heatproof dish and spread the haddock mixture over it. Pour the remaining cheese sauce over the haddock and sprinkle with the remaining cheese. Cook under a pre-heated grill until browned.

Garnish with the sprigs of chervil and serve.

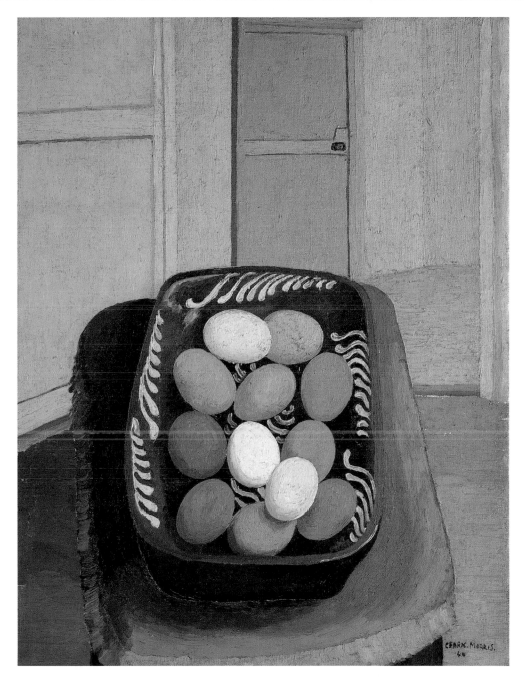

SIR CEDRIC MORRIS BT *The Eggs* 1944

Spinach and Lentil Roulade with Tomato and Basil Sauce

Serves 4

225 G / 8 OZ SPLIT RED LENTILS

SALT AND FRESHLY GROUND BLACK PEPPER

450 G / 1 LB FRESH SPINACH

3 TABLESPOONS OLIVE OIL

1 TEASPOON FRESHLY GRATED NUTMEG

1 TEASPOON GROUND GINGER

175 G / 6 OZ / 1½ CUPS PLAIN FLOUR

55 G / 2 OZ / ½ STICK BUTTER

6 EGGS

10 SPRIGS OF FRESH BASIL

Rinse the lentils. Place in a saucepan and cover with cold water. Bring to the boil and boil uncovered for 10 minutes, skimming occasionally. Cover and simmer for 20 minutes. Check the lentils as they simmer and add a little more water if they seem in danger of drying out. Season the cooked lentils with salt and freshly ground pepper and purée to a smooth paste in a food processor.

Wash the spinach thoroughly. Heat the olive oil in a large saucepan and add in the spinach, nutmeg, ginger, salt and freshly ground pepper. Cook until the spinach is just wilted. Drain and cool the spinach, squeeze it dry and purée it in a food processor.

Pre-heat the oven to Gas Mark 5/190°C/375°F. Line a 30 × 23 cm/ 12 × 9 inch Swiss roll tin with siliconised baking parchment. Sift the flour. Melt the butter in a saucepan over a low heat. Using an electric beater, whisk the eggs with a pinch of salt until they are stiff and foaming. Carefully fold the spinach purée and sifted flour into them. Fold in the melted butter.

Spread the mixture into the lined Swiss roll tin. Bake for 15–20 minutes until set; it should feel spongy to the touch and spring back when gently pressed. Cover with a damp cloth and leave to cool.

When the roulade is cool, turn it out on to a new sheet of siliconised baking parchment and carefully remove the old one. Spread the roulade with the lentil purée. Tear the basil and scatter over the purée. Carefully roll up the roulade lengthways.

Serve slices of the roulade with warm tomato and basil sauce (page 38).

Joan Cromwell Salad

This is a version of a seventeenth-century recipe from The Court and Kitchin of Elizabeth, commonly called Joan Cromwell, the Wife of the late Userper, *published in London in* 1664.

Serves 4

150 ML / 5 FL OZ / ⅔ CUP DOUBLE CREAM

2 TABLESPOONS LEMON JUICE

8 TABLESPOONS CHOPPED CHERVIL

225 G / 8 OZ FRENCH BEANS

125 G / 4 OZ FLAKED ALMONDS

2 DILL CUCUMBERS

450 G / 1 LB UNCOOKED PRAWNS IN THEIR SHELLS

1 TABLESPOON OLIVE OIL

PINCH OF GROUND GINGER

PINCH OF CAYENNE PEPPER

SALT AND FRESHLY GROUND BLACK PEPPER

25 G / 1 OZ CAPERS

50 G / 2 OZ SULTANAS

Make the chervil dressing: mix together the cream, lemon juice and chervil. Cover and refrigerate for 1 hour.

Top, tail and blanch the French beans. Dry-fry the flaked almonds until golden-brown. Slice the dill cucumbers. Peel and de-vein the prawns.

Heat the olive oil in a frying pan. When it is very hot add the prawns, ground ginger, cayenne pepper, salt and freshly ground pepper and stir-fry over high heat for 2 minutes. Set aside to cool.

Mix together the prawns, French beans, capers, dill cucumber slices, sultanas and flaked almonds.

Mix with the chervil dressing and serve.

Spinach and Brie Pithiviers with Coriander Sauce

Serves 4

450 G / 1 LB FRESH SPINACH

2 TABLESPOONS OLIVE OIL

SALT AND FRESHLY GROUND BLACK PEPPER

FRESHLY GRATED NUTMEG

1 EGG

225 G / 8 OZ BRIE

225 G / 8 OZ PUFF PASTRY

½ ONION

300 ML / 10 FL OZ / 1¼ CUPS MILK

55 G / 2 OZ / ½ STICK BUTTER

55 G / 2 OZ / ½ CUP FLOUR

55 G / 2 OZ SOFT GOAT'S CHEESE

SMALL BUNCH OF FRESH CORIANDER

Wash the spinach thoroughly. Heat the olive oil in a large saucepan and add the spinach. Season well with the nutmeg, salt and freshly ground pepper. Fry, stirring, until the spinach just begins to wilt. Drain and cool the spinach and squeeze dry. Beat the egg. Finely dice the Brie.

Roll out the puff pastry thinly and cut out four 10 cm/4 inch circles and four 15 cm/6 inch rounds. In each of the 15 cm/6 inch rounds cut six

crescent-shaped slits fanning out from the centre like spokes in a wheel. Lay the 10 cm/4 inch circles on a greased baking tray and put one-quarter of the spinach on each of them, leaving a pastry rim. Top with the diced Brie. Brush the pastry rims with the beaten egg. Lay the 15 cm/6 inch pastry rounds on top of each filled base and press the edges down firmly to seal them. Cover and chill in the refrigerator for 30 minutes.

Pre-heat the oven to Gas Mark 5/190°C/375°F. Brush the top of each pithivier with the beaten egg and bake for 30 minutes until the pithiviers are golden-brown with the Brie bubbling through the slits.

While the pithiviers are baking, make the coriander sauce: peel and chop the onion and place it in a saucepan with the milk, nutmeg, salt and freshly ground pepper. Bring to the boil and boil for 10 minutes. In a separate pan, melt the butter and mix in the flour and goat's cheese. Strain the flavoured milk slowly onto the cheese and flour mixture, stirring often and cooking over a very low heat until the cheese melts and the sauce thickens, about 15 minutes. Finely chop the coriander and blend it with the goat's cheese sauce until smooth.

Serve the pithiviers straight from the oven with warm coriander sauce.

Broccoli and Peanut Flan

Serves 6–8

Pastry

115 G / 4 OZ / 1 STICK BUTTER

1 EGG

1 TEASPOON SALT

225 G / 8 OZ / 2 CUPS PLAIN FLOUR

30–50 ML / 1–2 FL OZ / 2–4 TABLESPOONS MILK

Broccoli and Peanut Filling

350 G / 12 OZ BROCCOLI

½ ONION

1 TABLESPOON OLIVE OIL

85 G / 3 OZ DRY-ROASTED PEANUTS

4 EGGS

225 ML / 8 FL OZ / 1 CUP MILK

1 TABLESPOON PEANUT BUTTER

4 TABLESPOONS CHOPPED CHERVIL

SALT AND FRESHLY GROUND BLACK PEPPER

FRESHLY GRATED NUTMEG

First make the pastry: dice the butter. Beat one egg. Sift the flour and salt into a mixing bowl. Rub the butter into the flour with your fingertips. Add the beaten egg and milk and mix to form a dough. Alternatively, mix the sifted flour and salt, diced butter, beaten egg and milk in a food processor until a dough is formed. Wrap the dough in clingfilm and chill in the refrigerator for 30 minutes.

Pre-heat the oven to Gas Mark 4/180°C/350°F. Roll out the pastry and line a 20 cm/8 inch flan tin. Prick the bottom of the pastry case and line the pastry with siliconised baking parchment. Fill with baking beans and bake blind for 15 minutes. Remove the paper and beans and bake for a further 5 minutes. Set the pastry case aside to cool.

Meanwhile, make the broccoli and peanut filling: cut the broccoli into small florets, discarding the stalks, then steam or boil it until just tender.

FREDERICK WALKER *The Housewife* 1871

Drain (if boiled), cool and pat dry. Peel and finely chop the onion. Heat the olive oil in a frying pan and fry the onion over a low heat until softened.

Raise the oven temperature to Gas Mark 5/190°C/375°F. Place the broccoli, onion and peanuts in the pre-baked pastry case. Beat together the eggs, milk, peanut butter and chopped chervil. Season with salt, freshly ground pepper and the nutmeg. Pour the egg mixture over the broccoli and bake the flan for 30–40 minutes until set and golden-brown.

Puddings

Cinnamon Ice Cream in Brandy Snap Baskets

Serves 6

Cinnamon Ice Cream

568 ML / 1 PINT / 2½ CUPS MILK

1 CINNAMON STICK

1 TEASPOON GROUND CINNAMON

3 EGG YOLKS

115 G / 4 OZ / ½ CUP CASTER SUGAR

300 ML / 10 FL OZ / 1¼ CUPS DOUBLE CREAM

Brandy Snap Baskets

25 G / 1 OZ / ¼ STICK BUTTER

55 G / 2 OZ / ¼ CUP CASTER SUGAR

25G / 1 OZ GOLDEN SYRUP

25 G/ 1 OZ / ¼ CUP PLAIN FLOUR

1 TEASPOON GROUND GINGER

To make the cinnamon ice cream: place the milk, cinnamon stick and ground cinnamon in a saucepan. Heat through gently and bring to just below boiling point. Meanwhile, beat together the egg yolks and caster sugar until the mixture is pale yellow and fluffy. Strain the milk onto the eggs and sugar, whisking continuously as you do so. Return the mixture to the saucepan and heat gently over a heat diffuser, stirring constantly with a wooden spoon until it thickens into a custard. This can take 10–20 minutes and great care needs to be taken not to let the mixture curdle. To judge when it has thickened sufficiently, remove the spoon and look at the way the custard coats its back. The coating should be thick enough to hold a horizontal line drawn across it. Alternatively, if you have a sugar thermometer, stir the custard mixture until it reaches 85 °C / 185 °F. As soon as the custard reaches the right consistency remove it from the heat and pour it into a bowl to prevent curdling. Leave to cool. Fold in the double cream. If you have an ice-cream maker, churn the mixture according to

instructions and freeze in a plastic storage box. Alternatively, pour the mixture into a shallow polythene box and freeze, stirring thoroughly at half-hour intervals in order to achieve a suitable consistency.

To make the brandy snap baskets: pre-heat the oven to Gas Mark 4/ 190°C/350°F. Gently melt together the butter, sugar and golden syrup, stirring until the sugar has dissolved. Sift together the flour and ground ginger and beat into the melted mixture until well mixed.

Line a baking tray with siliconised baking parchment. Divide the brandy snap mixture into six portions and place two portions shaped into small circles well apart on the baking tray. Bake for 8–10 minutes until the mixture has spread into two brown, bubbly discs. Remove from the oven, cool for a minute, and place each disc over the base of a buttered 7.5 cm/ 3 inch dariole mould or a ramekin, pressing it quickly into a basket shape. Set aside to cool. Repeat the process to form six brandy snap baskets in all. Carefully remove the baskets from the dariole moulds or ramekins and store in an airtight container until needed.

To serve, place two scoops of cinnamon ice cream in each brandy snap basket.

PATRICK CAULFIELD *Second Glass of Whisky* 1992 (detail)

Whisky and Coffee Ice Cream

Serves 6

600 ML / 1 PINT / 2½ CUPS MILK

2 TABLESPOONS STRONG COFFEE

50 ML / 2 FL OZ / ¼ CUP WHISKY

3 EGG YOLKS

115 G / 4 OZ / ½ CUP CASTER SUGAR

300 ML / 10 FL OZ / 1¼ CUPS DOUBLE CREAM

Place the milk, coffee and whisky in a saucepan and slowly bring to the boil. Meanwhile, beat together the egg yolks and caster sugar until the mixture is pale yellow and fluffy. When the milk reaches just below boiling point, pour it on to the eggs and sugar, beating together well. Return the mixture to the saucepan and heat gently over a heat diffuser, stirring constantly with a wooden spoon until it thickens into a custard. This can take 10–20 minutes and great care needs to be taken not to let the mixture curdle. To judge when it has thickened sufficiently, remove the spoon and check the way the custard coats its back. The coating should be sufficiently thick to hold a horizontal line drawn across it. Alternatively, if you have a sugar thermometer, stir the custard mixture until it reaches 85°C/185°F. As soon as the custard reaches the right consistency remove it from the heat and pour it into a bowl to prevent curdling. Leave to cool. Fold in the double cream. If you have an ice-cream maker churn the mixture according to instructions and freeze in a terrine tin. Alternatively, pour the mixture into a shallow polythene box and freeze, stirring thoroughly at half-hour intervals in order to achieve a suitable consistency.

PIERRE BONNARD *Coffee* 1915

Poached Peaches in Filo Pastry with Whisky Cream

You will need four 6 cm / 2½ inch metal dariole moulds. If these are unavailable substitute four ramekins.

Serves 4

1 SLICE OF LEMON

1 SLICE OF ORANGE

115 G / 4 OZ / ½ CUP SUGAR

1 TEASPOON GROUND CINNAMON

2½ FL OZ / 70 ML / ⅓ CUP WHISKY

2 PEACHES

25 G / 1 OZ / ¼ STICK BUTTER

8 SHEETS OF FILO PASTRY

300 ML / 10 FL OZ / 1¼ CUPS DOUBLE CREAM

ICING SUGAR

SPRIGS OF MINT

Place the lemon slice, orange slice, sugar, ground cinnamon and 50 ml/ 2 fl oz/¼ cup of the whisky in a saucepan with 600 ml/1 pint/2½ cups water. Bring to the boil then reduce the heat, cover and simmer for 1 hour. Then bring the whisky syrup to the boil again and plunge the peaches into the syrup for 10–20 seconds, just long enough to loosen their skins. Set the peaches aside to cool. Boil the syrup uncovered until it has reduced by about three-quarters. Set aside to cool.

Pre-heat the oven to Gas Mark 6/200°C/400°F. Melt the butter in a saucepan over a low heat. Cut sixteen 15 cm/6 inch squares from the filo pastry sheets. Keep the filo squares covered with a damp tea-towel or a sheet of clingfilm so that they do not dry out and become brittle. Layer four filo squares into a star shape brushing each layer with melted butter. Press each filo star into a greased ramekin or 6 cm/2½ inch metal dariole mould. The points of the filo star should overlap the edges of the ramekin or mould. Repeat the process to make four filo cases in all. Bake the cases for 8–10 minutes until the filo is golden-brown. Allow to cool slightly then carefully turn out the cases and set them aside to cool.

Peel the blanched peaches carefully. Slice each peach in half and remove its stone. Whip the double cream and beat in the remaining whisky and icing sugar to taste.

To assemble the dessert, place 1 teaspoon of the whisky cream in the centre of each of four serving plates. Place a filo case on top of the cream so that it is held in place and divide the remaining cream among the four filo cases. Top each case with a peach half. Pour some syrup over each peach half and around the base of the pastry case.

Decorate with the sprigs of mint and serve at once.

ALLAN GWYNNE-JONES *Peaches in a Basket* 1948

Blackcurrant and Hazelnut Roulade

Serves 8

115 G / 4 OZ FROZEN BLACKCURRANTS

55 G / 2 OZ / ½ STICK BUTTER

115 G / 4 OZ / 1 CUP PLAIN FLOUR

175 G / 6 OZ / ¾ CUP SUGAR

4 EGGS

55 G / 2 OZ GROUND HAZELNUTS

55 G / 2 OZ / 1 CUP ICING SUGAR

300 ML / 10 FL OZ / 1¼ CUPS DOUBLE CREAM

Pre-heat the oven to Gas Mark 5/190°C/375°F. Line a 30 × 23 cm/12 × 9 inch Swiss roll tin with siliconised baking parchment. Defrost the blackcurrants in a colander, collecting the juice underneath and reserving it. Melt the butter in a saucepan over low heat. Sift the flour.

Using an electric mixer, whisk the sugar and eggs together until the mixture is stiff and foaming. Now use a spatula to fold in the flour and ground hazelnuts being careful not to over-mix. Quickly fold in the melted butter. Spread the mixture into the lined Swiss roll tin and bake for 25–30 minutes until the sponge mixture is set. To test it, press the sponge. If it springs back it is ready. Set aside to cool.

Boil the reserved blackcurrant juice and the icing sugar in an uncovered pan until it has reduced by half. Leave the syrup to cool.

Turn the roulade over onto a new sheet of siliconised baking parchment and carefully peel off the old sheet.

Whip the double cream and spread it on to the roulade. Sprinkle the blackcurrants evenly over the double cream. Carefully roll up the roulade lengthwise.

To serve, place a slice of the roulade on each plate and pour over a little of the blackcurrant syrup.

Right: PIERRE BONNARD *The Table* 1925

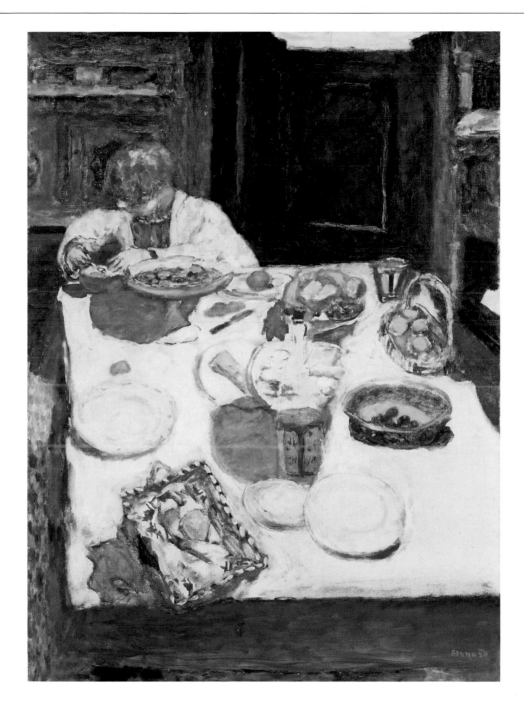

Minature Summer Puddings

You will need four 9 cm/3½ inch dariole moulds for this recipe.
If unavailable, substitute four ramekins.

Serves 4

500 G / 1 LB 2 OZ MIXED SOFT FRUIT (BLACKCURRANTS, BLUEBERRIES,
RASPBERRIES, REDCURRANTS, STRAWBERRIES)
175 G / 6 OZ / ¾ CUP CASTER SUGAR
125 ML / 4 FL OZ / ½ CUP RED WINE (OR THE JUICE OF 1 LEMON
MIXED WITH WATER TO MAKE 125 ML / 4 FL OZ LIQUID)
2 TABLESPOONS BRANDY
10 SLICES OF WHITE BREAD
1 TEASPOON CORNFLOUR

Place the soft fruit, caster sugar, red wine or lemon water and brandy in a saucepan. Gently heat through until the sugar is dissolved but do not let the liquid reach boiling point. Remove from heat, strain the fruit and reserve the juice.

Trim the crusts from the slices of bread and cut out four discs to fit the base of each dariole mould and four discs to form lids for the moulds. Halve the remaining two slices which will be used to line the moulds.

Dip the bread bases and halves briefly into the fruit juice and use them to line each dariole mould. Fill the bread-lined moulds with the fruit. Dip the bread lids into the fruit juice and cover each mould. Wrap the moulds tightly with clingfilm and place weights on top of them to press the summer puddings down. Chill for at least 4 hours or overnight.

Meanwhile, strain the remaining fruit juice into a saucepan and boil uncovered until the liquid has reduced by a half. Mix the cornflour with 2 teaspoons water. Remove the fruit juice from the heat, stir in the cornflour and return to the heat. Gently heat through, stirring, until the fruit sauce has thickened. Set aside to cool.

To serve, carefully turn the summer puddings out on to four plates. Pour the fruit sauce over them and serve.

Right: GEORGE WARNER ALLEN *Picnic at Wittenham* 1947–8

Steamed Ginger Puddings with Vanilla Sauce

You will need four 9 cm/3½ inch dariole moulds for this recipe.
If unavailable, substitute four ramekins.

Serves 4

Steamed Ginger Puddings

4 TABLESPOONS GOLDEN SYRUP

115 G / 4 OZ / 1 STICK BUTTER

115 G / 4 OZ / ½ CUP CASTER SUGAR

115 G / 4 OZ / ½ CUP PLAIN FLOUR

115 G / 4 OZ / ½ CUP SELF-RAISING FLOUR

1 TABLESPOON BAKING POWDER

2 TEASPOONS POWDERED GINGER

3 KNOBS OF STEM GINGER IN SYRUP

2 EGGS

2 TABLESPOONS MILK

Vanilla Sauce

600 ML / 1 PINT / 2½ CUPS MILK

1 VANILLA POD

4 EGG YOLKS

85 G / 3 OZ / ⅓ CUP CASTER SUGAR

150 ML / 5 FL OZ / ⅔ CUP DOUBLE CREAM

Grease four dariole moulds and place 1 tablespoon of golden syrup in the base of each mould. Cream the butter and sugar until pale and fluffy.

Sift together the flours, baking powder and powdered ginger. Finely chop the stem ginger. Beat the eggs then gradually beat them into the creamed butter and sugar, adding 1–2 tablespoons of the sifted dry ingredients to prevent curdling. When all the beaten egg is mixed in, fold in the rest of the sifted dry ingredients using a metal spoon. Carefully fold in the chopped stem ginger and the milk.

Divide the ginger mixture between the greased moulds, making sure that it does not fill the moulds to the top as it expands upon steaming. Cover the moulds tightly with clingfilm. Steam for 50 minutes until risen and set.

While the puddings are steaming make the vanilla sauce: gently heat the milk and vanilla pod in a saucepan for 10 minutes, then split the pod and scrape the seeds into the milk. In a separate bowl beat the egg yolks and sugar until pale and fluffy. Bring the milk to the boil and pour it over the beaten yolks, whisking well. Return the mixture to the pan. Heat gently, stirring constantly, over a heat disperser until it thickens slightly into a custard. If you have a sugar thermometer, stir the mixture until it reaches 85°C/185°F. Be very careful not to overheat it as it will curdle. Strain the custard and mix in the double cream.

To serve, carefully turn out the puddings and accompany with the vanilla sauce.

Pye with Fruit Ryfshews

Serves 8

Sweet Pastry

140 G / 5 OZ / 1¼ CUPS PLAIN FLOUR

PINCH OF SALT

85 G / 3 OZ / ⅓ CUP CASTER SUGAR

85 G / 3 OZ / ¾ STICK SOFTENED UNSALTED BUTTER

1 EGG

Fruit Ryfshews (or filling)

900 G / 2 LB MIXED SOFT FRUIT (BLACKBERRIES,
BLUEBERRIES, RASPBERRIES, STRAWBERRIES)

150 ML / 5 FL OZ RED WINE

115 G / 4 OZ CASTER SUGAR

JUICE OF 1 LEMON

Meringue Topping

4 EGG WHITES

225 G / 8 OZ / 1 CUP CASTER SUGAR

First make the sweet pastry: sift together the flour, salt and sugar onto a work surface.

Make a well in the centre of the sifted ingredients, then place the butter in the well and break the egg over it. Using your finger-tips, quickly pinch the egg and butter together until lightly blended. Using a knife or metal spatula chop the sifted dry ingredients into the egg and butter until the mixture resembles breadcrumbs and begins to cling together. Add a little water if necessary. Push the crumbly mixture gently into a ball of dough. If you have a food processor, mix all the pastry ingredients together until they form a lump of dough. Wrap the dough in clingfilm and chill for 30 minutes until firm.

Pre-heat the oven to Gas Mark 4/180°C/350°F. Roll the dough out on a floured board and line a greased 20 cm/8 inch flan tin with a removable base with the pastry. Prick the pastry base, line it with siliconised baking

parchment and fill with baking beans. Bake blind for 20 minutes. Remove the parchment and baking beans and bake for a further 10 minutes until pale gold. Remove and set aside to cool.

While the pastry case is baking make the fruit ryfshews filling: simmer the soft fruit with the wine, caster sugar and lemon juice until the sugar is dissolved. Strain the fruit and reserve the juice.

Pre-heat the oven to Gas Mark 4/180°C/350°F and prepare the meringue topping: beat the egg whites until soft peaks form then gradually fold in the caster sugar.

To assemble the pye, place the strained fruit in the pastry case and top with the beaten egg whites. Bake for 10 minutes until the meringue is lightly coloured. Leave to cool before cutting.

Serve with the reserved fruit juice and double cream.

WILLIAM HENRY HUNT *Fruit*

Lemon Tart

Serves 8

Sweet Pastry
140 G / 5 OZ / 1¼ CUPS PLAIN FLOUR

PINCH OF SALT

85 G / 3 OZ / ⅓ CUP CASTER SUGAR

85 G / 3 OZ / ¾ STICK SOFTENED UNSALTED BUTTER

1 EGG

Lemon Filling
JUICE AND GRATED ZEST OF 4 LEMONS

100 G / 3½ OZ / ½ CUP CASTER SUGAR

3 TABLESPOONS DOUBLE CREAM

5 LARGE EGGS

First make the sweet pastry: sift together the flour, salt and sugar on to a work surface.

Make a well in the centre of the sifted ingredients, then place the butter in the well and break the egg over it. Using your fingertips, quickly pinch the egg and butter together until lightly blended. Using a knife or metal spatula chop the sifted dry ingredients into the egg and butter until the mixture resembles breadcrumbs and begins to cling together. Add a little water if necessary. Push the crumbly mixture gently into a ball of dough. If you have a food processor, mix all the pastry ingredients together until they form a lump of dough. Wrap the dough in clingfilm and chill for 30 minutes until firm.

Pre-heat the oven to Gas Mark 4/180°C/350°F. Roll the dough out on a floured board and line a greased 20 cm/8 inch flan tin with a removable base with the pastry. Prick the pastry base, line it with siliconised baking parchment and fill with baking beans. Bake blind for 20 minutes. Remove the parchment and baking beans and bake for a further 10 minutes until pale gold. Remove and set aside to cool.

Make the lemon filling: whisk together the lemon juice and zest, sugar and double cream until thoroughly blended. Add the eggs one at a time, beating well after each addition.

FRANCES HODGKINS *Still life c.*1929

Pre-heat the oven to Gas Mark 5/190°C/375°F. Pour the lemon mixture
into the pre-baked flan case and bake for 15–20 minutes until set.

Bitter Chocolate Mousse

Serves 4

140 G / 5 OZ / 1¼ CUPS HIGH COCOA-CONTENT DARK CHOCOLATE

5 EGG WHITES

25 G / 1OZ / ⅛ CUP CASTER SUGAR

2 EGG YOLKS

1 TABLESPOON RUM OR GRAND MARNIER (OPTIONAL)

Break the chocolate into squares and melt it in a bowl over simmering water. Set the chocolate aside to cool slightly. Beat the egg whites until soft peaks form, then add the caster sugar and whisk until stiff.

Stir the egg yolks into the melted chocolate, mixing well. Mix in the rum or Grand Marnier if using. Briskly mix one-third of the beaten egg whites into the chocolate mixture, then gently but quickly fold in the remaining egg whites. Chill for at least 3 hours before serving.

Chocolate and Raspberry Roulade

Serves 8

Roulade
175 G / 6 OZ / ¾ CUP CASTER SUGAR PLUS EXTRA FOR DUSTING

6 EGGS

125 G / 4½ OZ / 1⅛ CUPS SELF-RAISING FLOUR

40 G / 1½ OZ / ⅓ CUP COCOA POWDER

Chocolate and Raspberry Filling
300 ML / 10 FL OZ / 1¼ CUPS DOUBLE CREAM

125 G / 4 OZ FRESH RASPBERRIES

55 G / 2 OZ GRATED DARK CHOCOLATE

First make the roulade: pre-heat the oven to Gas Mark 4/180°C/350°F. Line a Swiss roll tin with siliconized baking parchment. Dust another sheet of baking parchment thickly with caster sugar. Whisk the eggs with the caster sugar until the mixture is thick, pale and fluffy and has increased three-fold in bulk. Sift together the flour and cocoa powder and fold into the eggs and caster sugar with a metal spoon. Spread the mixture over the lined Swiss roll tin. Bake for 15–20 minutes until risen and springy to the touch. Remove from the oven and turn on to the sheet of baking parchment that has been dusted with caster sugar. Carefully peel off the old sheet.

Make the chocolate and raspberry filling: whip the double cream and spread it evenly over the chocolate roulade. Scatter the raspberries and grated chocolate over the cream.

Carefully roll up the roulade lengthways.

Brioche and Butter Pudding

Serves 4

25 G / 1 OZ / ¼ STICK UNSALTED BUTTER

3 BRIOCHE ROLLS

55 G / 2 OZ MIXED DRIED FRUIT

(SULTANAS, RAISINS, CURRANTS, CANDIED PEEL)

2 EGGS

55 G / 2 OZ / ¼ CUP CASTER SUGAR

300 ML / 10 FL OZ / 1¼ CUPS MILK

FEW DROPS OF VANILLA ESSENCE

55 G / 2 OZ FLAKED ALMONDS

ICING SUGAR

Melt the butter in a saucepan over low heat. Generously grease four ramekins with some of the butter. Place a disc of siliconised baking parchment in the base of each dish. Pre-heat the oven to Gas Mark 4/ 180°C/350°F.

Cut the crusts off the brioche rolls. Slice the brioche into small cubes and mix with the dried fruit. Fill the buttered ramekin dishes with this mixture. Pour the remaining melted butter over the brioche-filled ramekins.

Whisk the eggs and sugar until pale and creamy. Heat the milk and vanilla essence in a saucepan. When the milk reaches just below boiling point pour it into the whisked eggs, stirring constantly. Return the milk and egg mixture to the saucepan and heat gently over a heat disperser, stirring constantly, until it thickens slightly into a custard. If you have a sugar thermometer, heat gently, stirring, until the mixture reaches 85°C/ 185°F. Be very careful not to overheat the mixture or it will curdle. Pour the custard into the brioche-filled ramekins and sprinkle with the flaked almonds.

Place the ramekins in a deep roasting tray and pour in enough hot water to reach halfway up the dishes. Bake for 20–30 minutes until golden-brown and set. Meanwhile, sift the icing sugar.

Carefully turn the brioche puddings out of the ramekins, place on serving dishes, dust with the icing sugar and serve.

JAMES TISSOT *Holyday* *c.*1876 (detail)

Old English Sherry Trifle

This is based on a recipe from An Encyclopaedia of
Domestic Economy *by Thomas Webster and
Mrs William Parkes (London, 1844).*

Serves 8

Pastry Cream
1 TABLESPOON GROUND MIXED SPICE
600 ML / 1 PINT / 2½ CUPS MILK
3 EGG YOLKS
75 G / 3 OZ / ⅓ CUP CASTER SUGAR
2 TABLESPOONS CORNFLOUR

Roulade
5 EGGS
200 G / 7 OZ / ⅞ CUP CASTER SUGAR
140 G / 5 OZ / 1¼ CUPS PLAIN FLOUR
3 TABLESPOONS RASPBERRY JAM
55 G / 2 OZ FLAKED ALMONDS
600 ML / 1 PINT / 2½ CUPS DOUBLE CREAM
225 G / 8 OZ FRESH RASPBERRIES OR THAWED FROZEN RASPBERRIES
225 ML / 8 FL OZ / 1 CUP SHERRY

First make the pastry cream: add the mixed spice to the milk and bring to
the boil. Meanwhile, beat the egg yolks and sugar until pale and fluffy.
Using a metal spoon, fold the cornflour into the beaten yolks, mixing
thoroughly. When the milk reaches just below boiling point, pour half of
it onto the yolks and whisk well. Add the yolk mixture to the remaining
milk. Beat well over medium heat until the mixture is thick and lump free.
Set aside to cool and chill until required.

Make the roulade: pre-heat the oven to Gas Mark 4/180°C/350°F. Line
a Swiss roll tin with siliconised baking parchment. Whisk the eggs with
140 g/5 oz/⅝ cup of the caster sugar until the mixture is thick, pale and
fluffy and has increased three-fold in bulk. Sift the flour and fold it into

PAUL CÉZANNE *Still Life with Water Jug* c.1892–3

the eggs and caster sugar with a metal spoon, mixing thoroughly. Spread the mixture evenly over the lined Swiss roll tin. Bake for 15–20 minutes until golden-brown and risen. Sprinkle the remaining caster sugar evenly over a sheet of the baking parchment. Turn the roulade out onto the sugared paper and peel off the old sheet. When the roulade is cool, spread it with the raspberry jam and roll up from the long edge.

Dry-fry the flaked almonds until golden-brown. Whip the double cream until fluffy. Slice the roulade into 1 cm / ½ inch thick slices and place half of them in a serving bowl. Top with the raspberries and then the remaining roulade slices. Pour the sherry evenly over the slices then spread the chilled pastry cream over them. Top with the whipped double cream and sprinkle with the flaked almonds.

Fresh Fruit Salad

Serves 8

1 SMALL MELON

1 PAPAYA

1 SMALL PINEAPPLE

1 MANGO

1 PINK GRAPEFRUIT

2 ORANGES

1 PASSION FRUIT

55 G / 2 OZ WHITE GRAPES

55 G / 2 OZ BLACK GRAPES

115 G / 4 OZ STRAWBERRIES

115 G / 4 OZ RASPBERRIES

115 G / 4 OZ BLUEBERRIES

Halve the melon and scoop out the seeds. Slice each half lengthwise into three segments, cut off the skin and cut the flesh into chunks. Repeat the process for the papaya. Cut the top and bottom off the pineapple. Quarter lengthwise and cut out the tough core and skin. Cut the flesh into chunks. Slice the mango in half around each side of the large stone. Remove the skin and cut the flesh into chunks. Cut the skin off the grapefruit and one orange, removing any pith. Cut into segments. Halve the passion fruit and scoop out the pulp, discarding the skin. De-stalk and halve the grapes and remove the pips. Hull and halve the strawberries.

Mix the prepared fruits in a serving bowl. Scatter the raspberries and blueberries over them. Squeeze the juice of the other orange and pour it over the fruit salad.

Cover and chill until ready to serve.

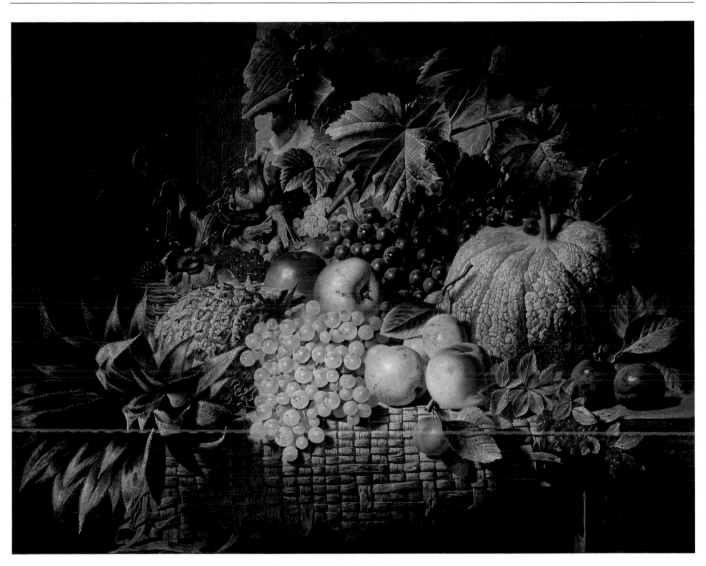

GEORGE LANCE *Fruit Piece*

Pears and Raspberries in Filo
with Orange Caramel

Serves 4

4 RIPE FIRM DESSERT PEARS

1 LEMON

115 G / 4 OZ FRESH RASPBERRIES OR THAWED FROZEN RASPBERRIES

55 G / 2 OZ / ½ STICK UNSALTED BUTTER

6 SHEETS OF FILO PASTRY

ICING SUGAR

Poaching Syrup
350 G / 12 OZ / 1½ CUPS SUGAR

1 VANILLA POD

Orange Caramel Syrup
225 G / 8 OZ / 1 CUP SUGAR

JUICE AND GRATED ZEST OF 1 ORANGE

Peel the pears but retain the stalks. Remove the cores from the bottom end of the pears with a corer. Slice the lemon and cover the peeled, cored pears with cold water and lemon slices to prevent discolouring.

Make the poaching syrup: boil the sugar and vanilla pod in 850 ml/1½ pints/3½ cups water until the sugar has dissolved.

Drain the pears and lemon slices and add them to the syrup. Cover and simmer until the pears are just tender, around 5 minutes. Remove from the heat. Cool the pears in the syrup then drain them and fill them with the raspberries.

Pre-heat the oven to Gas Mark 4/180°C/350°F. Melt the butter in a saucepan over a low heat. Cut the filo sheets into 12 squares large enough to wrap around a pear. Cover the squares with a damp tea-towel or a sheet of clingfilm to prevent them drying out and becoming brittle. Sparingly brush three filo squares with the melted butter and layer them on top of each other to form a star shape. Place a raspberry-filled pear in the centre of the filo star and wrap the pastry up over the fruit, squeezing

PABLO PICASSO *Dish of Pears* 1936

it together at the top of the pear and leaving the stalk sticking out. Brush the pastry-covered pear with melted butter. Repeat the process to make four filo-covered pears in all. Place the pears on a well-greased baking sheet and bake for 20–30 minutes until golden-brown.

Meanwhile, make the orange caramel: bring the sugar and 75 ml/ 2½ fl oz/⅓ cup water to the boil and continue to boil over a high heat until the sugar has melted and the syrup turns an amber caramel colour. Remove from the heat, cool slightly and stir in the orange juice and rind. Re-heat, stirring well to remove any lumps. Stir in 50 ml/2 fl oz/¼ cup water to make a syrup.

Divide the orange caramel syrup between four serving dishes. Place the baked pears on top of the syrup and sift a dusting of icing sugar over them.

Serve with cream, créme fraîche or natural yoghurt.

Lemon Soufflé

Serves 6

2 EGGS

10 G / ¼ OZ LEAF GELATINE

JUICE AND GRATED ZEST OF 2 LEMONS

175 G / 6 OZ / ¾ CUP CASTER SUGAR

300 ML / 10 FL OZ / 1¼ CUPS DOUBLE CREAM

Separate the eggs. Soften the gelatine in the lemon juice. Gently heat the lemon juice and gelatine, being careful not to let the mixture boil, until the gelatine dissolves. Set aside to cool.

Whisk the egg yolks with the caster sugar until pale yellow and fluffy. Whip the double cream until stiff and fold it into the eggs and caster sugar with a metal spoon.

Whip the egg whites until stiff. Fold the egg whites and the grated zest into the cream with a metal spoon. Gently fold in the cooled gelatine. Divide the mixture between six ramekins. Cover and chill for 2 hours.

RIGHT: DUNCAN GRANT *The Kitchen* 1902

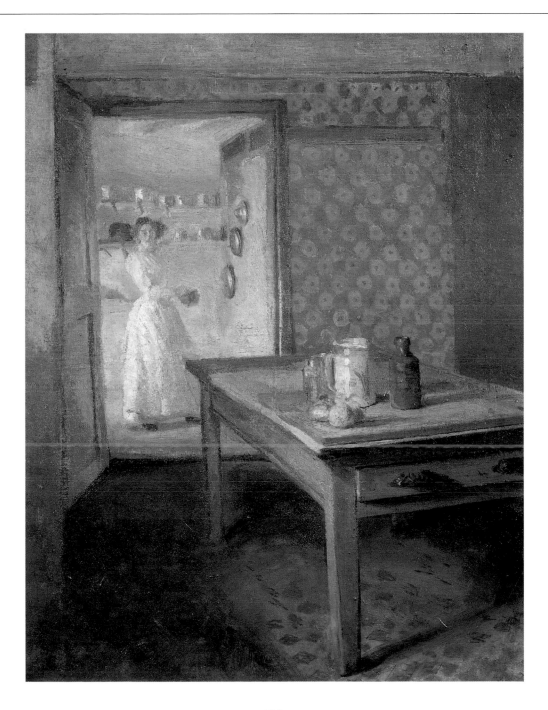

Eight-layer Chocolate Torte

You will have to plan ahead as the meringue discs have to be cooled overnight and the assembled dessert must be chilled for at least 8 hours. You will need a 20 cm/8 inch ring mould with a removable base.

Serves 10

Meringue Discs
4 EGG WHITES
225 G / 8 OZ / 1 CUP CASTER SUGAR
350 G / 12 OZ / 3 CUPS GROUND HAZELNUTS

Fillings
350 G / 12 OZ WHITE CHOCOLATE
225 G / 8 OZ MARSHMALLOWS
350 G / 12 OZ DARK CHOCOLATE
600 ML / 1 PINT / 2½ CUPS DOUBLE CREAM
JUICE AND GRATED ZEST OF 1 LIME
1 TABLESPOON DRAMBUIE
125 G / 4 OZ FRESH RASPBERRIES
125 G / 4 OZ TOASTED FLAKED ALMONDS
3 DROPS OF ALMOND ESSENCE

First make the meringue discs: pre-heat the oven to Gas Mark 4/180°C/ 350°F. Whisk the egg whites until soft peaks form. Add half the caster sugar and whisk until firm. Whisk in the remaining sugar and fold in the ground hazelnuts.

Mark out four circles just slightly smaller than the 20 cm/8 inch ring mould on siliconised baking parchment. Spread the meringue mixture to cover these circles. Bake the meringue discs for 10–15 minutes until just lightly coloured. Leave to cool in the oven overnight. If your oven is not large enough to take four discs at once, cook them in batches of two and store the first batch in an airtight container while the second batch cools in the oven.

To make the filling: break the white and dark chocolate into pieces.

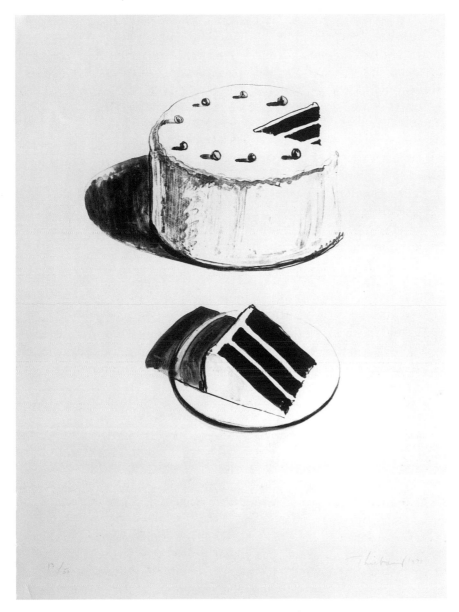

WAYNE THIEBAUD *Chocolate Cake* 1971

Place the white chocolate, 125 g/4 oz of the marsh-mallows and ½ pt/ 300 ml of the double cream in a heatproof basin. Cover the basin with foil and place it over a pan of simmering water, stirring now and then, until the marshmallows and chocolate have melted and mixed together. Set aside to cool.

Place the dark chocolate, the remaining marshmallows and ½ pt/300 ml of the double cream in a heatproof basin. Cover the basin with foil, and place over a pan of simmering water, stirring now and then, until the marshmallows and chocolate have melted and mixed together. Set aside to cool.

Divide each chocolate mixture into two portions. Stir the lime juice and zest into one portion of the white chocolate mix. Stir the Drambuie into the remaining portion of the mix. Fold the raspberries into one portion of the dark chocolate mix. Stir the flaked almonds and almond essence into the other portion of the mix. Chill the fillings slightly.

To assemble the dessert, line a 20 cm/8 inch ring mould with siliconised baking parchment. Place one meringue disc inside the mould and spread with the lime-flavoured mixture. Top with a second meringue disc and spread this with the raspberry-flavoured mixture. Top with a third meringue disc and spread this with the Drambuie mix. Top this with the fourth meringue disc and spread this evenly with the almond-flavoured mix. Cover and chill for at least 8 hours.

To serve, carefully remove from the ring mould and slice with a sharp knife that has been dipped in hot water and then dried.

List of Illustrations

GEORGE WARNER ALLEN *Picnic at Wittenham* 1947–8
Oil on tempera on canvas laid on wood 121.9 × 121.9 cm
Presented by Paul Delaney executor of the
artist's estate 1992

VANESSA BELL *Pheasants* 1931
Oil on canvas 90.8 × 73 cm
Presented by Sir Kenneth Clark (later Lord Clark of
Saltwood) through the Contemporary Art Society 1946
© Angelica Garnett

ELIZABETH BLACKADDER *Still Life with Pomegranates* 1963
Oil on canvas 86.4 × 111.8 cm
Presented by the Trustees of the Chantrey Bequest 1966

PIERRE BONNARD *Coffee* 1915
Oil on canvas 73 × 106.4 cm
Presented by Sir Michael Sadler through the National Art
Collections Fund 1941
© ADAGP Paris and DACS London

PIERRE BONNARD *The Table* 1925
Oil on canvas 102.9 × 74.3 cm
Presented by the Courtauld Fund Trustees 1926
© ADAGP Paris and DACS London

GEORGES BRAQUE *Bottle and Fishes* c.1910–12
Oil on canvas 61.6 × 74.9 cm
Purchased 1961 © ADAGP Paris and DACS London 1996

JOHN BRATBY *Still Life with Chip Frier* 1954
Oil on board 131.4 × 92.1 cm
Presented by the Contemporary Art Society 1956

MARCEL BROODTHAERS *Casserole and Closed Mussels* 1964
Mussel shells, pigment and polyester resin in painted iron
30.5 × 27.9 × 24.8 cm
Purchased 1975 © Estate Marcel Broodthaers

MARCEL BROODTHAERS *The Farm Animals* 1974
Print on paper 81.9 × 60.3 cm
Purchased 1980

PATRICK CAULFIELD *Second Glass of Whisky* 1992
Acrylic on canvas 61 × 76.5 cm
Presented by the Trustees of the Chantrey Bequest 1993
© Patrick Caulfield 1996 All rights reserved DACS

PAUL CÉZANNE *Still Life with Water Jug* c.1892–3
Oil on canvas 53 × 71.1 cm
Bequeathed by C. Frank Stoop 1933

CHARLES COLLINS *Lobster on a Delft Dish* 1738
Oil on canvas 70.5 × 91 cm
Purchased 1981

WILLIAM COLLINS *Prawn Fishing* 1828
Oil on wood 43.5 × 58.4 cm
Presented by Robert Vernon 1847

SALVADOR DALÍ *Lobster Telephone* 1936
Various media 17.8 × 33 × 17.8 cm
Purchased 1981
© DEMART PRO ARTE BV/DACS 1996

RAOUL DUFY *Olive Trees by the Golfe Juan* c.1927
Watercolour on paper 50.8 × 66 cm
Presented by the Contemporary Art Society 1936
© DACS 1996

STANHOPE ALEXANDER FORBES *The Health of the Bride* 1889
Oil on canvas 152.4 × 200 cm
Presented by Sir Henry Tate 1894

CHARLES GINNER *The Café Royal* 1911
Oil on canvas 63.5 × 48.3 cm
Presented by Edward Le Bas 1939

DUNCAN GRANT *The Kitchen* 1902
Oil on canvas 50.8 × 40.6 cm
Presented by the Trustees of the Chantrey Bequest 1959

DUNCAN GRANT *Still Life with Carrots* c.1921
Oil on canvas 50.8 × 68.6 cm
Bequeathed by Sir Edward Marsh through the
Contemporary Art Society 1953

JOHN GRIFFIER THE ELDER *A Turkey and other Fowl in a Park* 1710
Oil on canvas 114.6 × 139 cm
Purchased 1985

ALLAN GWYNNE-JONES *Peaches in a Basket* 1948
Oil on canvas 34.3 × 43.2 cm
Presented by the Trustees of the Chantrey Bequest 1954

WILLIAM HOGARTH *O the Roast Beef of Old England
('The Gate of Calais')* 1748
Oil on canvas 78.8 × 94.5 cm
Presented by the Duke of Westminster 1895

FRANCES HODGKINS *Still Life* c.1929
Drawing on paper 37.8 × 44.5 cm
Presented by Miss Lilian Harmston in accordance with the
wishes of Arthur Rowland Howell 1957

WILLIAM HENRY HUNT *Fruit*
Watercolour on paper 21.6 × 27.3 cm
Presented by Charles Fraser 1905

LESLIE HUNTER *Kitchen Utensils* c.1914–18
Oil on wood 45.7 × 38.1 cm
Presented by William McInnes 1935

GEORGE LANCE *Fruit Piece*
Oil on canvas 35.7 × 45.9 cm
Bequeathed by Mrs Elizabeth Vaughan 1885

FERNAND LÉGER *Still Life with a Beer Mug* 1921–2
Oil on canvas 92.1 × 60 cm
Purchased with assistance from the Friends of
the Tate Gallery 1976
© ADAGP/SPADEM Paris and DACS London 1996

ALPHONSE LEGROS *Le Repas des Pauvres* 1877
Oil on canvas 113 × 142.9 cm
Presented by Rosalind Countess of Carlisle 1912

SIR CEDRIC MORRIS BT *The Eggs* 1944
Oil on canvas 61.5 × 43.2 cm
Presented by Elizabeth David CBE 1992

BALTHAZAR NEBOT *Covent Garden Market* 1737
Oil on canvas 64.8 × 122.8 cm
Purchased 1895

SIR WILLIAM NICHOLSON *Mushrooms* 1940
Oil on canvas and board 34.9 × 45.1 cm
Purchased 1941 © Elizabeth Banks

PABLO PICASSO *Dish of Pears* 1936
Oil on canvas 38 × 61 cm
Bequeathed by Mrs A.F. Kessler 1983
© Succession Picasso/DACS 1996

CAMILLE PISSARRO *The Pork Butcher* 1883
Oil on canvas 65.1 × 54.3 cm
Bequeathed by Lucien Pissarro the artist's son 1944

ALAN REYNOLDS *Summer: Young September's Cornfield* 1954
Oil on board 102.2 × 154.9 cm
Presented by the Trustees of the Chantrey Bequest 1956

WILLIAM SCOTT *Mackerel on a Plate* 1951–2
Oil on canvas 55.9 × 76.2 cm
Purchased 1954

WALTER RICHARD SICKERT *Roquefort* c.1918–20
Oil on canvas 41 × 32.4 cm
Presented by the Contemporary Art Society 1924

SIR STANLEY SPENCER *Apple Gatherers* 1912–13
Oil on canvas 71.4 × 92.4 cm
Presented by Sir Edward Marsh 1946
© Estate of Stanley Spencer 1996 All rights reserved DACS

SIR STANLEY SPENCER *Dinner on the Hotel Lawn* 1956–7
Oil on canvas 94.9 × 135.9 cm
Presented by the Trustees of the Chantrey Bequest 1957
© Estate of Stanley Spencer 1996 All rights reserved DACS

WILLIAM STRANG *Bank Holiday* 1912
Oil on canvas 152.7 × 122.6 cm
Presented by F. Howard through the National Loan
Exhibition Committee 1922

WAYNE THIEBAUD *Chocolate Cake* 1971
Monoprint lithograph on paper 44.5 × 33 cm
Purchased 1982

JAMES TISSOT *Holyday* c.1876
Oil on canvas 76.2 × 99.4 cm
Purchased 1928

J.M.W. TURNER *Study of Fish: Two Tench, a Trout and a Perch*
c.1822–4
Pencil and watercolour 27.5 × 47 cm
Bequeathed by the artist 1856

FREDERICK WALKER *The Housewife* 1871
Gouache on paper 17.8 × 25.4 cm
Bequeathed by R.H. Prance 1920

REX WHISTLER *The Expedition in Pursuit of Rare Meats* 1926–7
Tate Gallery Restaurant mural in a wax medium

Index